Photography

SHREWSBURY
SIXTH FORM COLLEGE

Unlocking potential...Shaping futures

This book is due for return on or before the last date shown below

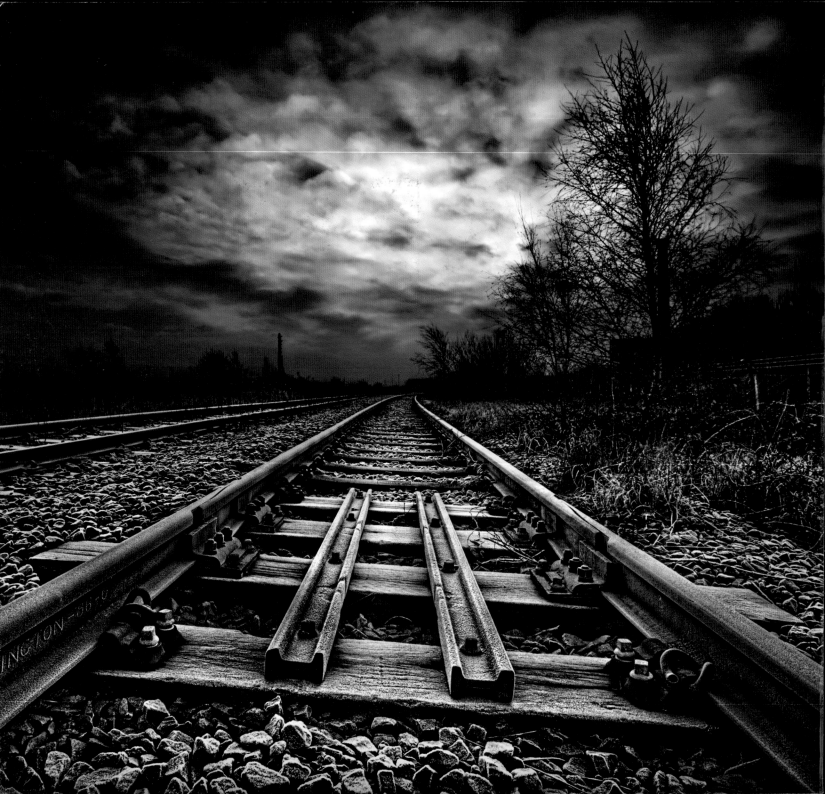

Practical HDR

The complete guide to creating High Dynamic
Range images with your digital SLR

David Nightingale

ILEX

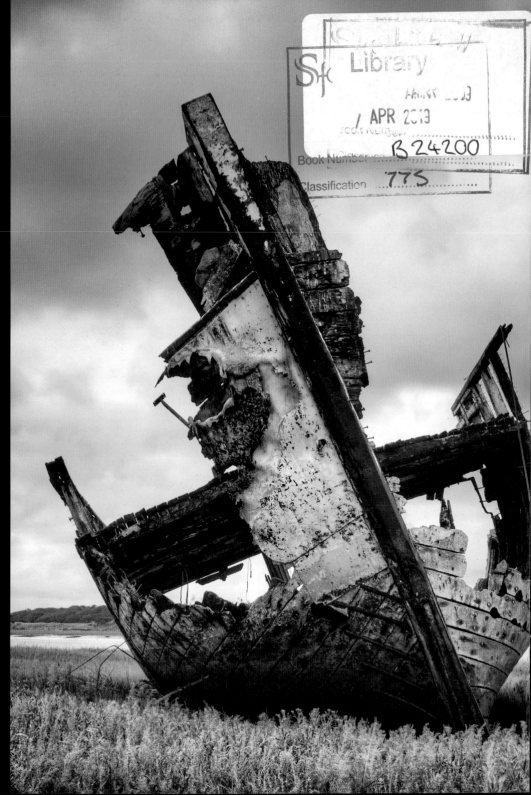

First published in the United Kingdom
in 2009 by:

I L E X

210 High Street
Lewes
East Sussex
BN7 2NS
www.ilex-press.com

Publisher: Alastair Campbell
Creative Director: Peter Bridgewater
Managing Editor: Chris Gatcum
Art Director: Julie Weir
Senior Designer: Emily Harbison
Designer: Richard Wolfströme

British Library Cataloguing-in-Publication Data
A catalogue record for this book is available from
the British Library.

ISBN 978-1-905814-63-3

Printed and bound in China

10 9 8 7 6 5 4

Contents

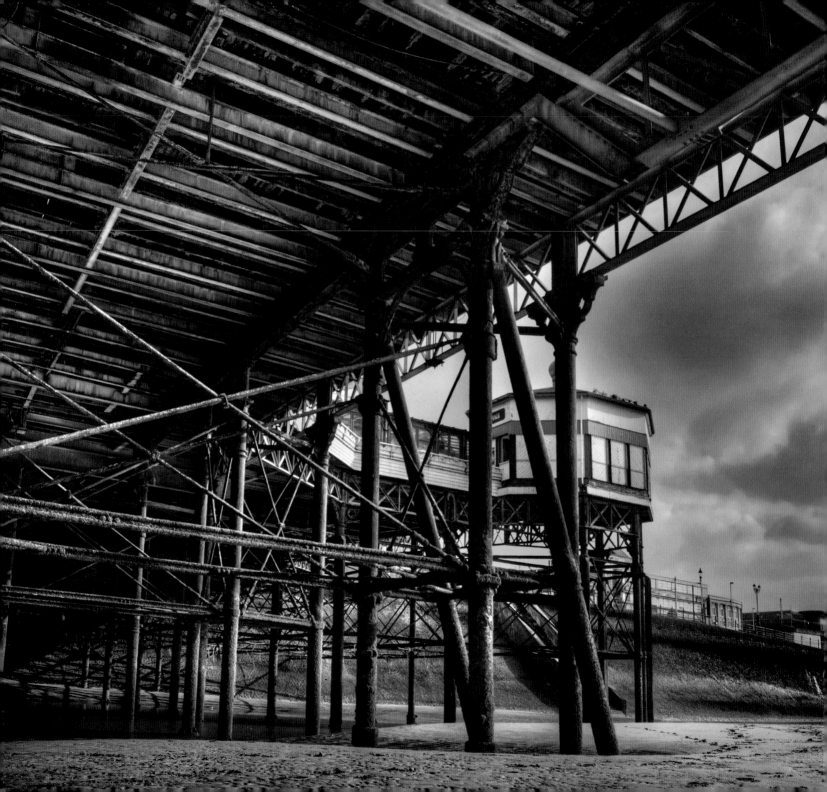

Introduction

When I started out in photography, one of the things I found most frustrating was that my camera seemed to have a totally different view of the world to me. Where I saw a glorious sunset, my camera saw an overexposed wash of pale colors; where I saw clouds floating over a beautiful landscape, my camera saw a flat white sky, or a dark foreground, or both; and backlit portraits would all end up as silhouettes. With practice, I learnt a variety of techniques that improved my photography: using exposure compensation, setting my camera to Manual, and using different metering patterns to assess a scene. In other words, I developed a better understanding of how to compensate for the various ways in which my camera's perception of the world was more limited than my own.

At the same time, I also learnt that there are some shots that you just can't take— at least not without using additional lighting, reflectors, neutral density graduated filters, and so on. These are the shots where the contrast is so high that some areas of the image will end up overexposed, underexposed, or both. The problem is that while our eyes can see a full range of tones in these high contrast scenes, our digital cameras cannot.

This problem isn't a new one, and the earliest photographers looked for different ways to record high contrast, or "high dynamic range" images. In the 1850's, Gustave Le Gray produced a number of dramatic seascapes constructed from two negatives—one exposed for the sea, the other for the sky. He cut both negatives along the horizon, then used the two parts to create a single photographic print. In this way he was able to capture all of the detail in the scene, which would have been impossible with a single exposure. Motivated by the same problem, Charles Wyckoff developed a wide dynamic range film composed of three layers, each of which had a different sensitivity to light. He used this to produce photographs of nuclear explosions, which first appeared on the cover of Life Magazine in the 1940's.

But it wasn't until much more recently that what we now commonly refer to as High Dynamic Range, or HDR, photography began to develop. In 1985, Gregory Ward created the Radiance RGBE file format for HDR images—a format that is still in use today— while in 1993, Steve Mann reported creating a tone mapped image from a sequence of exposures of normal digital images. The idea was simple—shoot a sequence of exposures that covered the full brightness range of the image, and combine them into a single, high dynamic range picture that would contain detail in everything from the brightest highlight to the deepest, darkest shadow.

This sounds straightforward, but there are numerous issues that can make it far from easy. To start with, you need to be able to meter the scene to calculate the number of exposures to make to capture the entire dynamic range. You also need to know how to deal with any significant movement between the frames, and you have to understand how to create and "tone map" your images to create a final picture that meets your creative expectations. As you will see in this book, once you understand these issues, HDR imaging is a powerful technique that can be used to produce photographs that are simply not possible through any other means.

Chapter 1:
Understanding Dynamic Range

Real World Dynamic Range

One of the first things you learn as a photographer is that the way you perceive a scene is often quite different to how your camera evaluates and processes the same data. For example, a shot you intend as a backlit portrait may well end up as a silhouette, a shot of a brightly lit scene may end up looking too dark, and so on. In other words, the image you see is sometimes not the one you manage to take.

There are two main reasons for this. The first is that your camera will attempt to set an optimum exposure for a particular shot, so it will set the aperture or shutter speed, or both, to ensure that enough light hits the sensor to produce a well-exposed image.

The problem is, your camera assumes an average level of illumination for every shot you take so, if you shoot in a dark room, the image may well end up brighter than the original scene as your camera bases it's exposure on an average level of illumination. By the same token, a shot of a person, backlit by a bright sky, may produce a shot with a beautifully exposed sky but no detail in your subject's face— again because the camera works on the assumption that all pictures are taken under "average" lighting conditions.

The second reason your images may not end up as you intend them is because of the difference between the way in which you see things and how your camera records them. While you might see a richly detailed landscape, set against the backdrop of a bright, but cloudy sky, the camera will be likely to deliver a picture where the sky looks as you intended, but the foreground is too dark, or, with a correctly exposed foreground, but an overexposed, blank white sky. Worst of all, you might get an image with both a featureless sky and an overly dark foreground. In this instance, adjusting the exposure won't fix the problem, it will just present you with a different once—increasing the exposure to compensate for an overly dark foreground will overexpose the sky, while decreasing the exposure to retain the detail in the sky will lead to a very dark foreground.

A correctly exposed
sky with an overly
dark foreground

A correctly exposed
foreground with an
overexposed sky

An image containing
areas of under and
overexposure

An HDR image lets you combine the brightest and darkest parts of a scene that your camera wouldn't be able to record in a single shot.

The problem is that the "dynamic range" of the scene you are trying to photograph is larger than your camera can record. At its simplest, dynamic range is the ratio between the lightest and darkest tones in an image, and this is measured in EV (Exposure Value), which refers to the combinations of shutter speed and relative aperture that give the same exposure. Additional terms that are often used in this context are "f-stops" and "contrast ratio."

When we view a scene, we can perceive a range of between 10-14EV (or f-stops), and if we take into account the fact that our eyes can adjust to different levels of brightness this increases to around 24EV. But digital cameras can only record an EV range of 5-9 stops, so if the scene contains an EV range of around 9 or more, there is no combination of

aperture or shutter speed that will allow you to capture the entire dynamic range of the original scene. All you can do is optimize the exposure for the shadow detail or the highlight detail, but you will inevitably lose one or the other.

From a photographic point of view, there are three solutions. First, you can simply avoid taking shots where you know that the size of the EV range will compromise the quality of the final image. In the case of a landscape shot this might mean waiting until the balance of light between the brightest and darkest areas of the scene falls within a smaller EV range.

Second, you could use a graduated neutral density (ND) filter to darken the brightest areas of the image. These can darken a portion of an image in increments from 1-3EV and are

especially useful for landscape photography as the sky can often be a lot brighter than the foreground. However, the gradation on the filter is fixed, so it is generally only suitable if there is a clear "dividing line" between the light and dark areas of the scene—useful for a landscape with a flat horizon, but less useful for images where the bright and dark areas are irregularly shaped.

Finally, you can shoot a range of different exposures that record the detail in both the deepest shadows and the brightest highlights, and then combine them into a High Dynamic Range (HDR) image, which is clearly the key topic for the remainder of this book.

JPEG files distribute the data in a slightly different way to Raw files. While there is still a bias toward the highlight detail, the number of levels allocated to each area of brightness is more evenly distributed, as illustrated in the accompanying grid.

12 bit RAW file	Levels
1: Highlight areas	2048
2: Bright areas	1024
3: Midtones	512
4: Dark areas	256
5: Shadow areas	128

8 bit JPEG file	Levels
1: Highlight areas	69
2: Bright areas	50
3: Midtones	37
4: Dark areas	27
5: Shadow areas	20

Digital Sensors and Contrast Ratios

Your eyes and your camera's sensor respond to light in a similar way, with photons striking a receptor (either your retina or the photosites on the sensor). This generates a signal, the strength of which is proportional to the amount of photons striking the receptor within a given amount of time. With the eye, exposure to light is continuous, and the effect on the retina decays over time, but with a camera the effect is additive—the shutter opens, photons are collected in the photosites for a finite period of time, and then the shutter closes. At this point, the photons are "counted" to produce a digital signal indicating the amount of light that was received during the exposure.

The reason a typical digital camera can capture an EV range of between 5 and 9 stops is because each photosite on your camera's sensor has a specific capacity, and once it reaches the maximum limit the signal it outputs is the same, irrespective of how many further photons strike it. In other words, it's like a bucket: once it's full there is no way to add any further content. This is significant, as differences in brightness can only be recorded in terms of the differences in the number of recorded photons. For example, if the capacity of each photosite was a maximum of 1024 photons, then the maximum theoretical EV range it could

record would be 10EV (2^{10} levels). In practice, this theoretical limit can never be reached as recording detail in the very darkest areas of an image is inaccurate due to the inherent noise that sensors generate, and no analog to digital converter is sufficiently accurate to distinguish between single photons.

Another problem is that while a 12-bit RAW file is capable of recording a theoretical maximum of 4,096 levels of brightness, the amount of data allocated to the different levels of brightness within the scene varies, with half (2,048) allocated to the brightest areas, half of the remaining 2,048 allocated to the next brightest areas, half of the remaining 1,024 to the next, and so on, as outlined in the grid at left. This means considerably more data is used to record detail within the brighter areas of the image. With a normal photograph this isn't especially significant, but with an HDR image—especially one where you really want to maximize the amount of detail in all areas of the image—the shadow detail becomes much more significant, and if you haven't recorded sufficient levels of detail in the darker areas the conversion process will struggle to produce a "clean" image, resulting in noise, banding, or other digital artifacts in the darker areas of the converted image.

Contrast ratios of other devices

Although it would be easy to think that the solution to dealing with high dynamic range images is simply to develop cameras with sensors that can record a higher dynamic range to start with, we also need to consider how our photographs will be displayed. Our cameras are capable of recording roughly 5-9EV, which equates to a contrast ratio of 32:1-512:1, but as noted, the dynamic range of an actual scene can be quite a bit higher; the EV range of a shot containing very bright highlights and very deep shadows could be around 14EV, which is a contrast ratio of 16,384:1. Even if our camera could record this level of data there are very few ways in which we could display the image. A photographic print typically has a contrast ratio of around 300:1, while a standard computer monitor has a contrast ratio of approximately 500:1. So even if your camera could record a much larger EV range, most standard output devices are Low Dynamic Range devices and could not display it. There are a number of High Dynamic Range monitors that have a claimed contrast ratio of around 200,000:1, but these are incredibly expensive, and unlikely to be available to the domestic market any time soon.

Using and Understanding the Histogram

Understanding the histogram is essential to every stage of producing an HDR image. You will need to use your in-camera histogram to calculate the EV range you need to shoot, to evaluate the individual shots in a bracketed exposure sequence, to change a variety of settings when you convert your HDR images, and to judge images during any subsequent post-production. In short, it's an important tool that can provide invaluable feedback as you work your way through every stage of the HDR process.

We've already examined the relationship between the EV range of a scene and the dynamic range of your camera's sensor and, as noted, the former can often be larger than the latter, resulting in areas of over or underexposure in your images. A related term is "tonal range," which basically refers to the range and distribution of the tones between the lightest and darkest areas of an image. For example, an image with a wide tonal range will include both dark and light areas (and a range of tones in between), whereas an image with a narrow tonal range will be predominantly composed of midtones. The range and distribution of tones is graphically represented using a histogram, which is a graph with two axes. The horizontal axis shows the distribution of tones from black (at the left) to white (at the right), while the height of the graph indicates the number of pixels at any given tonal value, so the higher the peak on a histogram, the more pixels are within the image at this point.

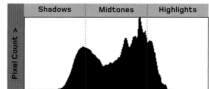

In this example you can see that the data is clumped towards the middle of the histogram. This indicates two things. First, it shows that the tonal range is reasonably narrow—there are no blacks or whites, so no deep shadows or bright highlights. In other words, the majority of the tones cover the midtone values. Second, it tells us that the EV range of the original scene was smaller than the dynamic range of the camera's sensor, as all the data within the original scene "fits" within the horizontal axis.

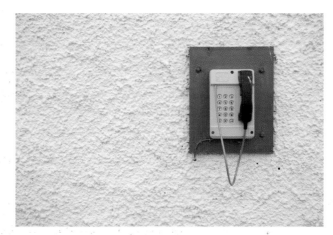

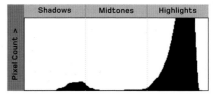

The entire EV range of the original scene has also been captured in this shot, but the shape of the histogram is very different to the first one. There is a large clump of data to the right of the histogram, and a much smaller clump toward the left. The large peak on the right represents the wall, while the smaller clump represents the darker areas of the phone on the red, wood board.

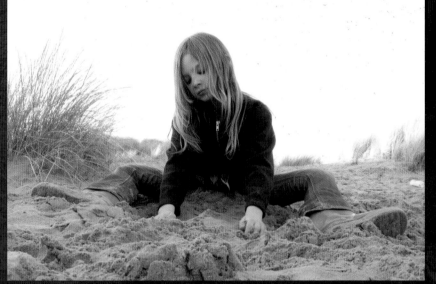

Shadows	Midtones	Highlights

Pixel Count >

In this example, the histogram is butted up to the right-hand edge. This indicates that a portion of the picture is over-exposed, and if you take a look at the original image you can see why. I set the exposure to record a good range of tones in the foreground, but because the EV range of the original scene was quite high, this caused the brightest areas of the image to be "clipped" from the histogram, meaning they ended up as pure white in the photograph.

Shadows	Midtones	Highlights

Pixel Count >

This image contains quite large areas of underexposed data, and the shadow and foreground detail have been lost. In this instance this is indicated by "clipping" at the leftmost edge of the histogram, where a range of areas within the original capture are black. Increasing the exposure would shift the histogram to the right, and recover some shadow detail, but perhaps not all of it.

What all these examples demonstrate is that the histogram can provide invaluable data regarding your initial exposures and, in the case of your in-camera histogram, is an instant way to accurately assess both the EV range of the scene your are photographing and the tonal range your camera has captured.

By accurately assessing your histogram you can make sure your final HDR image contains a full tonal range.

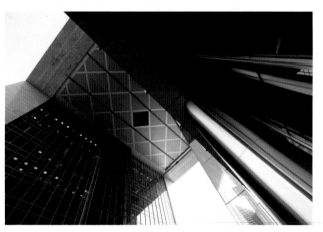

In the final example you can see that both the shadow and highlight areas have been clipped, meaning there are areas of pure black and pure white in the image. This means the EV range of the original scene is considerably larger than the dynamic range of the camera's sensor. Adjusting the exposure to record more highlight detail would make the shadows worse, and vice versa.

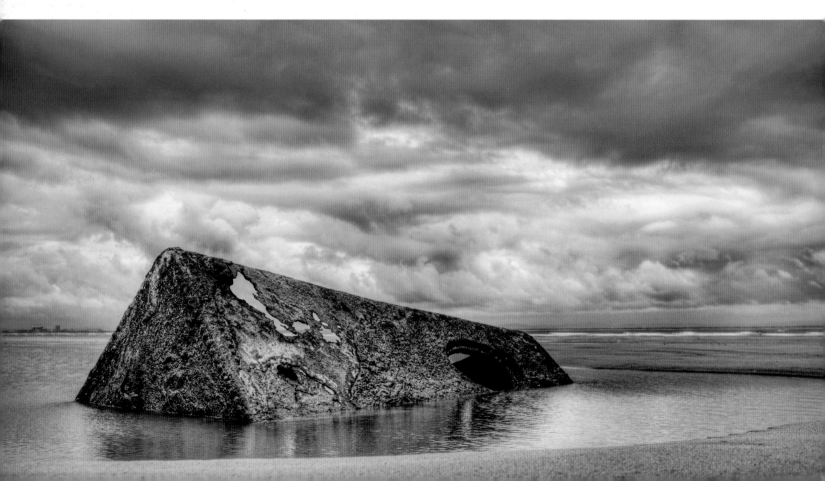

RGB and Brightness histograms

The histograms in the previous examples are all brightness histograms, which read the scene as a whole. However, some digital cameras let you to switch to an RGB histogram that shows the three color channels (red, green, and blue) individually. An RGB histogram will often be more accurate as, while the brightness histogram might indicate that your exposure contains no shadow or highlight clipping, the RGB histogram might indicate that the highlight exposure for the green and blue channels is OK, but that the data in the red channel is overexposed, for example. Avoiding over- and underexposure is definitely one of the things you should aim for when shooting sequences of images to process into an HDR image, and as such, anything that can aid you in avoiding exposure errors is definitely something you should embrace.

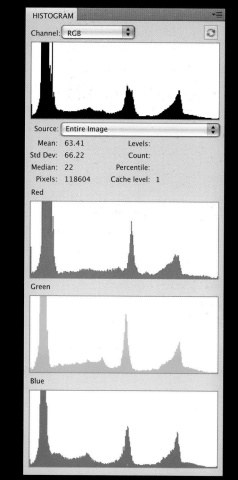

An in-camera RGB histogram

Histograms in Photoshop

When working in Photoshop, you can also assess your images using a histogram, by choosing Window>Histogram to open the Histogram Palette. The default histogram shows a brightness histogram, similar to the in-camera versions we just looked at, but you can also call up RGB histograms for your images.

To switch the display to show the RGB histogram, click the dropdown menu at the top-right of the histogram palette and select All Channels View. This will display the three channel histograms, as well as the original composite display. This can be especially useful during post-production to prevent you inadvertently clipping the detail in either the shadows or highlights of an individual channel. To make sure this doesn't happen, switch your camera to the RGB histogram as often as possible, and make sure that you get into the habit of routinely previewing your exposures as you shoot them. If you notice any under- or overexposure in one or more of the three channels, adjust your exposure and take the shot again.

Photoshop's "All Channels View" histogram

Photoshop's default brightness histogram

HDRI and Tone Mapping Explained

Sunset in Dubai

When the EV range of a scene is larger than the dynamic range of the camera you have no option other than to accept that some of the detail cannot be recorded in a single image, and you will have to sacrifice shadow detail, highlight detail, or both. In many cases, this isn't a problem—simply set your exposure to make sure that the areas of the scene you are most interested in are adequately exposed. In this example, I set my exposure to capture the sunset and the bright reflections in the water, allowing the young woman in the foreground to become a silhouette. This works well, and the loss of detail creates a more subtle, enigmatic image.

-2EV

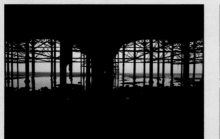

-1EV

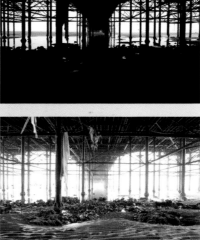

Metered exposure

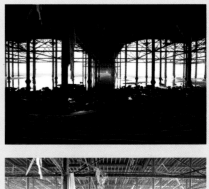

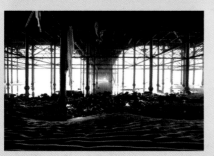

+1EV

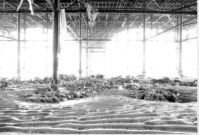

+2EV

+3EV

But, if you take a look at the histograms of the lightest and darkest images, you will see that the sequence as a whole covers the entire EV range of the scene, with no clipped highlights in the darkest exposure, and no clipped shadows in the lightest.

In this example, the EV range of the original scene is about 5EV (or stops) larger than my camera's dynamic range, so a sequence of images from -2EV to +3EV is required to successfully capture the entire dynamic range. Having done this, the next step is to combine, or convert, this sequence into a single High Dynamic Range (HDR) image. The term "High Dynamic Range"—or "High Dynamic Range Image" (HDRI)—is often used to

The histogram for the darkest exposure (-2EV)

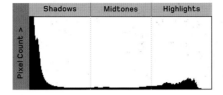

The histogram for the lightest exposure (+3EV)

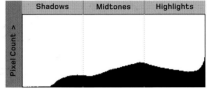

label a particular style of picture, but, technically, this name is incorrect. As an HDR image is a 32-bit image it cannot be displayed or printed on conventional low dynamic range (LDR) devices such as computer monitors or printers. In other words, most—if not all—of the HDR images you have seen (including those in this book) are actually LDR images, albeit created using a variety of HDR techniques.

Indeed, HDR images themselves are visually quite dull, at least when displayed on a standard monitor or the printed page. This is because we can only display a portion of the full dynamic range, so a "pure" 32-bit HDR file of the pier doesn't really look any better than any of the original images in the exposure sequence, and still displays a substantial amount of clipping in both the shadow and highlight areas.

So, while an HDR image may contain all the data from the original scene—in both the shadow and highlight areas—we can't see all of the detail if we are viewing it on a conventional LDR device. This means creating an HDR file is only a part of the story, and this story isn't complete until we convert it back into an LDR image using a process called "tone mapping."

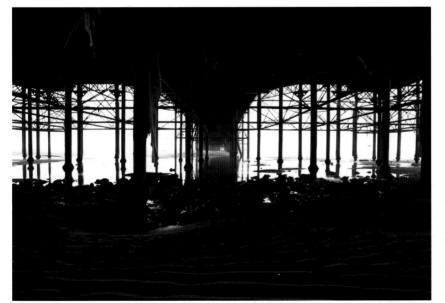

32-bit HDR file

A "typical" HDR image contains all the data from the original scene

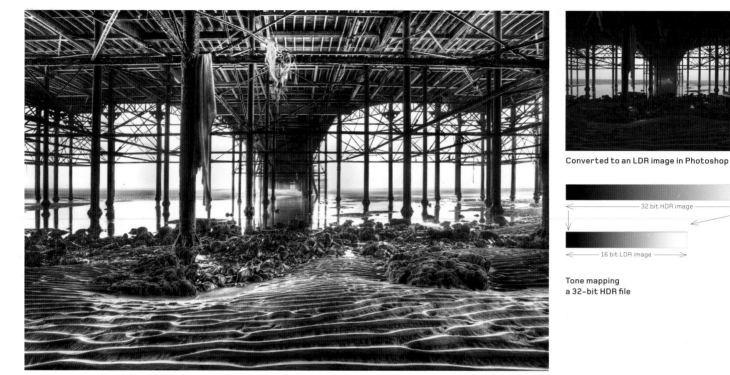

Converted to an LDR image in Photoshop

Tone mapping
a 32–bit HDR file

Converted to an LDR image in Photomatix Pro

Tone mapping

At its most basic, tone-mapping a 32-bit HDR image simply involves compressing the image data into a range that can be printed or displayed. If we use one of Photoshop's most basic tone mapping methods (as discussed in chapter 4) we can compress this HDR picture of the pier into a 16-bit (or 8-bit) file that contains a full range of tones in both the shadow and highlight areas.

As you can see though, converting the image in this way still doesn't produce an especially good result. While we do now have a full range of tones in both

the shadow and highlight areas of the image, the underside of the pier and the foreground are both still very dark, and the sky and brighter areas of the image lack any detail.

This is because this particular form of tone mapping applies a global algorithm to the 32-bit HDR image, so every pixel is converted—or "mapped"—in the same way. Essentially, the luminance of each pixel is altered in a uniform way to ensure that all the data fits into the smaller luminance range of the LDR image.

While these global forms of tone mapping can produce good results

when the variance in luminance is evenly distributed, a form of "local" tone mapping will often produce a better result. Local tone mapping adjusts each pixel in relation to the value of the surrounding pixels in the image, rather than treating them all the same. The math behind this process is extremely complex, but the result is an increase to the local contrast in different areas of an image by unequal amounts. As the final version of the pier image, using the localized tone mapping algorithms in Photomatix Pro to convert the image has produced a considerably more striking picture (above).

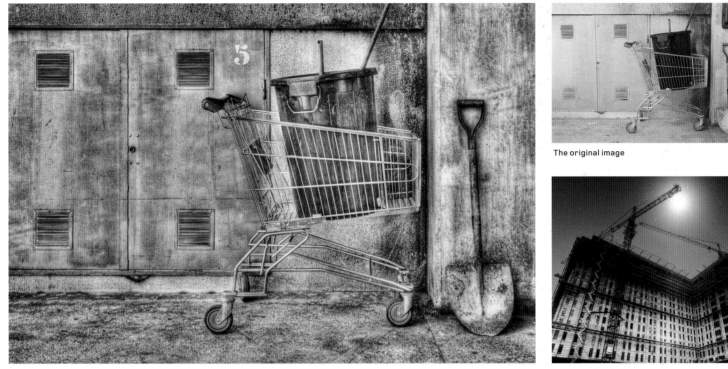

A tone mapped HDR image

The original image

Increased local contrast

In this example, there is now a high degree of contrast in the foreground of the image and the underside of the pier—areas that were quite dark when converted using one of Photoshop's simpler methods. There is also much greater detail and contrast in the brighter areas of the image. Put simply, using a local tone mapping algorithm has produced a much better image.

Throughout this book, the majority of the techniques will concentrate on local tone mapping algorithms to produce an LDR image, though the extent to which this effect is applied will vary, depending on the result we are looking for.

The image of the shopping cart and trash can (above), looks more like an illustration than a photograph once the HDR file has been converted into an LDR image. The final image was produced from a single Raw file (a technique covered in chapter six) and was processed to maximize the local contrast. In the original shot, the trash can is very dark, but in the tone-mapped version it shares the same tonal range as other sections of the image. In other words, the naturally occurring global contrast in the original—where some areas of the image are clearly darker than others—has been all but removed in the final, tone mapped image.

By comparison, the tone mapped image of a building and cranes—which required seven bracketed exposures to capture the entire dynamic range—looks far more natural. Although the dynamic range of the original scene was very high, less local contrast was introduced at the tone-mapping stage, allowing the darker areas to remain quite dark and the lighter areas to retain a higher amount of brightness. As a result, the final image looks far more photo-realistic than the shopping cart, but both images would still be labeled "HDR."

Chapter 2:
Shooting for HDR

Camera Settings and Equipment

Having explained the basic principles of HDR photography, it's time to turn our attention to the practicalities of the process; the equipment you need, how to meter a scene with a larger EV range than your camera's sensor, and how to shoot a bracketed sequence of exposures to maximize the quality of your final image. The good news is that you don't need a great deal of kit to produce stunning HDR images—in fact, you may already have everything you need to get started.

For HDR photography, you can use either a compact, or a digital SLR camera, but it must let you adjust the shutter speed while holding the aperture constant. As you are probably aware, there are three ways to alter the exposure of a photograph; by changing the aperture, the shutter speed, or the ISO. When shooting HDR sequences, you only want to adjust the shutter speed between exposures. Altering the aperture varies the depth of field, so if you shoot a sequence of images at different apertures, the content of each image will be different, making it difficult, if not impossible, to combine the sequence into a single image.

If you look at the three images below (taken at aperture settings of f/4, f/8, and f/16) you will see that while they are shots of the same scene, the content is very different. In this instance, this isn't a bracketed sequence—each is based around the metered exposure—but they demonstrate the point; it would be impossible to generate a coherent HDR image from a sequence of images that each had a different depth of field.

Shot at f/4

Shot at f/8

Shot at f/16

Varying the ISO will also produce images that have different content, although in this instance it will be in terms of the amount of noise within the image. If you wanted to shoot a three image sequence with a 2EV (or 2-stop) interval between the frames, for example, you would need to shoot at ISO 100 for the darkest shot, ISO 400 for the metered exposure, and ISO 1600 for the lightest shot. As you may have already found, the higher the ISO, the noisier the image, with red,

green, and blue speckles starting to appear in the image. Even if you were using the best DSLR currently available, there would still be appreciably more noise in the shot taken at ISO 1600 than either of the other two exposures. Again, if you tried to combine this sequence to create an HDR image, the result wouldn't be great, so stick to adjusting the shutter speed—and only the shutter speed—when you shoot a sequence of images for HDR.

DSLR
DSLRs are great for HDR photography as they offer full manual control over your exposures.

Superzoom
Superzooms normally offer Aperture priority and Manual modes, so are also good for HDR.

High-end compact
Only a few high-end compact cameras offer the controls you need for HDR photography.

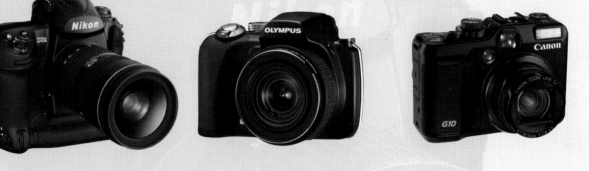

Auto-bracketing

Virtually all DSLRs, and some compact digital cameras, let you automatically bracket your exposures, letting you shoot a minimum of three frames, with one at the metered exposure, one that is underexposed, and one that is overexposed. To use auto-bracketing for an HDR sequence you should ensure that you select Aperture Priority mode, as this will fix the aperture and vary the shutter speed to change the exposure during the sequence.

If the EV range of the original scene can be captured using an auto-bracketed sequence (this will depend on the EV range of the scene and the level of control your camera offers) then this is the best method to use. Not only will your camera shoot the sequence as quickly as possible—minimizing any potential subject movement between exposures—but the likelihood that you will move the camera's position during the sequence is also minimized.

Exposure compensation

If your camera doesn't have an auto-bracketing facility, it may well have an exposure compensation feature, which can also be used to shoot an HDR sequence. Set your exposure compensation to underexpose by -2EV and take a shot, then readjust your camera to the metered exposure (0EV) and take a second shot. Finally, dial in +2EV to take the lightest shot in the sequence. Nearly ever compact camera—and most DSLRs—limits you to a range of ±2EV exposure compensation, but this is often sufficiently wide to capture a basic HDR sequence.

Shooting in Manual mode

An alternative to using auto-bracketing or exposure compensation is to switch your camera to its Manual mode and change the shutter speed between each exposure. This isn't ideal—it takes longer, is prone to error, and may well result in you moving the camera between exposures—but may be the only viable alternative if the EV range of the original scene is very high.

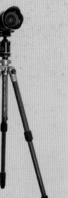

Tripod

Although all you really need to shoot a sequence of images for HDR work is a camera that can vary its shutter speed, there are other pieces of equipment that could be considered. These start with a tripod, which many photographers already consider an essential part of their kit. All of the HDR programs we will be discussing later in this book incorporate algorithms that will attempt to align the images from an auto-bracketed sequence. This makes it possible to shoot a handheld sequence of images, especially when shooting a relatively small number of exposures using auto-bracketing, but it doesn't always work. Even if you think you can keep your camera relatively steady, I would still recommend using a tripod to lock your camera into position. Sturdier models often produce better results—especially if you need to alter any of the settings on your camera during the exposure sequence—but the bottom line is any tripod is better than no tripod.

Remote release

A cable, or remote release, will also help reduce the risk of you inadvertently moving your camera during an exposure sequence. This is especially important when one or more shots in the exposure sequence will be taken with a long exposure, as any camera movement will inevitably cause some degree of camera shake.

If you don't have a remote release—or your camera doesn't have the facility to use one—try using the self-timer instead. Again, this will minimize the chances of you moving your camera either between or during your various exposures.

Lens hood

A lens hood is incredibly useful when shooting HDR sequences as it will reduce the likelihood of your final image containing any lens flare. Flare is especially problematic in HDR as the process of constructing the images often involves maximizing the contrast within an image. As such, any flare in an exposure sequence will also be maximized, which should be avoided.

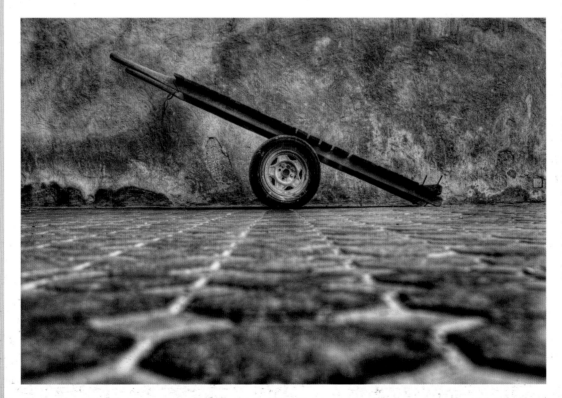

If you don't have a tripod, or don't have one with you, try bracing your camera against the ground, a nearby wall, or other object. The key consideration is keeping your camera as still as possible, both during and between exposures.

For the seven shot sequence I used to create this image of a handcart, I simply rested the camera on the ground. This had the added benefit of producing a more creative shot than I would have done if the camera had been higher off the ground.

For low-light photography
a tripod is essential—not
just for HDR.

Metering the Dynamic Range of a Scene

One of the key stages in creating an HDR image is to make sure that the sequence of images you shoot captures the entire dynamic range of the original scene, so the lightest image captures a full range of tones in the shadow areas, and the darkest image doesn't clip any of the highlight detail. If you don't achieve this at the capture stage, your final HDR image will inevitably contain clipped shadows, highlights, or both.

In chapter six we will be discussing how to use HDR techniques to enhance a low contrast scene, where the entire dynamic range could be captured in a single shot. In these cases all you need to do is shoot a set of three auto-bracketed exposures (with an EV spacing of 1-2EV) based around the metered exposure.

In cases when the dynamic range isn't especially high, and just a bit larger than can be captured in a single shot, shooting an auto-bracketed sequence of three images will probably also be sufficient. If you look at the three images and histograms of the metal structure in the sea you can see that the metered exposure almost captures the full dynamic range, with only minor clipping of the shadow detail. In this situation, having shot the metered exposure and checked the histogram, you could be confident that a three shot auto-bracketed sequence would be sufficient to capture a full range of tones in both the shadow and highlight areas.

However, when the EV range is significantly larger than the camera's

dynamic range, things get a bit more complicated. If we take a look at the sequence of images that were used to construct the crane image on page 21, you can see that the dynamic range of the original scene was very high—around 10EV larger than my camera's dynamic range.

In this instance, an auto-bracketed sequence of three shots would not be enough to capture the entire dynamic range, so you need to evaluate the scene—prior to shooting the sequence—to determine the correct exposure for your lightest and darkest image, and decide how many images you need to shoot between the two extremes.

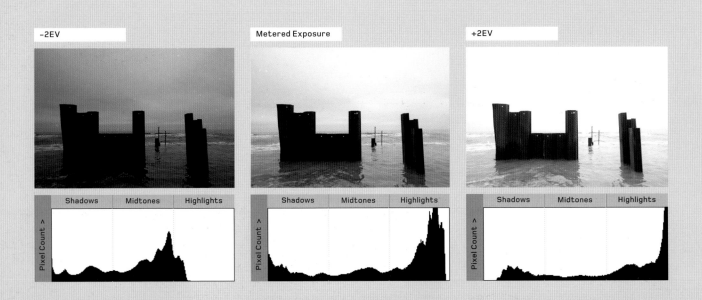

-2EV

Metered Exposure

+2EV

Shadows	Midtones	Highlights

Pixel Count >

Shadows	Midtones	Highlights

Pixel Count >

Shadows	Midtones	Highlights

Pixel Count >

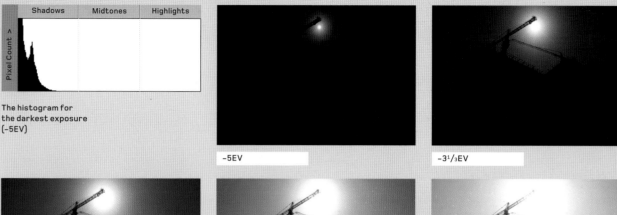

The histogram for
the darkest exposure
(–5EV)

–5EV

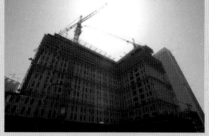

–3¹/₃EV

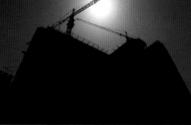

–1²/₃EV

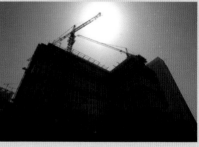

0EV

+1²/₃EV

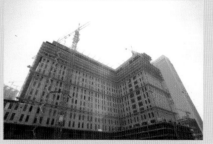

+3¹/₃EV

+5EV

The histogram for
the lightest exposure
(+5EV)

Using a spot meter

The easiest way to assess the scene is to use a spot meter—either a handheld meter, or the spot metering function in your camera, if it has it. To meter the darkest and lightest areas of the original scene, enter the aperture you are going to use (Aperture Priority mode is good

for this), then meter each area, recording the indicated shutter speed for both. If the darkest area of the scene requires a shutter speed of ¼ sec, for example, and the lightest area needs a 1/125 sec exposure, this indicates there are 6 stops (a 6EV gap) between these two extremes, so you would need to shoot seven exposures with a 1EV gap between

them, or four using a 2EV spacing. Switch your camera to Manual mode, set the aperture, and shoot the sequence. Start with either the lightest or darkest image and manually adjust the shutter speed between exposures until you have shot the entire sequence.

A Sekonic spot meter

Trial and Error

If you don't have a spot meter, or a spot metering option built into your camera, you can use a process of trial and error to determine the exposures you need. Switch your camera to Manual mode, then adjust the aperture and shutter speed to the metered exposure that the camera suggests. Adjust the shutter speed to 2EV below its current setting (if the metered exposure is 1/60 sec, change it to 1/250 sec, for example), and take a shot. Check your histogram for highlight clipping, and if there is any, increase the shutter speed by a further 2 stops (2EV) and take a second shot. Again, check the histogram, and if the image still isn't dark enough, repeat the process until you reach a point where the highlights aren't clipped. Once you do, make a note of the settings as this will be the darkest exposure in your image sequence.

Now, repeat the process to determine the shutter speed you need for your brightest shot (the shadow detail), this time increasing the shutter speed and checking for clipping at the opposite end of the histogram. When there is no clipping, you have found the settings for the lightest exposure. You can now shoot a sequence of images, starting with the lightest and adjusting the shutter speed until you reach the setting for the darkest shot.

Optimum Exposure

On the face of it, both of these histograms look fairly similar, and both indicate there is no loss of shadow detail. However, because digital sensors record far less detail in the shadow areas of an image, you should make sure that the left most edge of your histogram for the lightest exposure isn't close to or touching the leftmost edge of the display.

So, although both of these histograms show there is no clipping, the first one (A) is the ideal starting point for an HDR sequence.

A

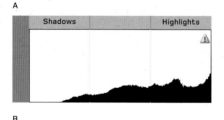

B

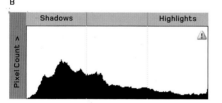

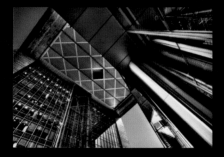

This seven shot sequence of the DIFC (Dubai International Financial Center) is a typical example of shooting a series of images specifically for HDR. If you a look at the histogram for the first image, you will see that a considerable amount of the shadow detail has been lost (indicated by the left edge of the graph going "off the scale"), but there are no blown highlights at the right.

Likewise, if you examine the histogram for the final (+3EV) image in the sequence, you will see that although the entire sky is blown out—along with many other lighter areas—a full range of tones has been captured in the shadows. The images between these extremes fill the gaps and, in this instance, the intermediary images were spaced 1 stop (1EV) apart. As you can see from the combined histogram, the dynamic range of the original scene is almost 12 stops (12EV), which is far beyond the capabilities of anything other than dedicated high dynamic range imaging equipment.

Having shot my initial sequence of seven frames, I was able to produce a tone mapped image containing a full range of tones in both the brightest and darkest areas of the image, with no visible noise, even in the darkest areas.

Shooting a Bracketed Exposure Sequence

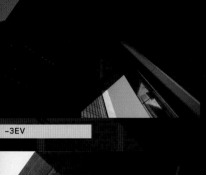

−3EV

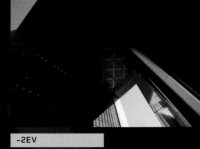

−2EV

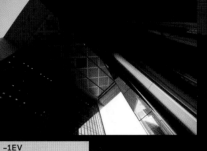

−1EV

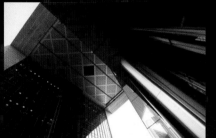

Metered exposure

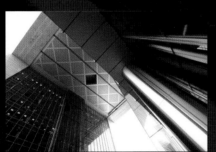

+1EV

The histogram for the darkest exposure (−3EV)

Shadows	Midtones	Highlights

The histogram for the lightest exposure (+3EV)

Shadows	Midtones	Highlights

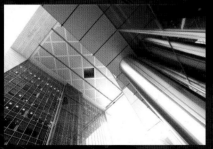

+2EV

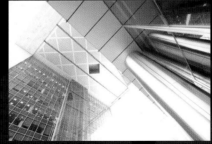

+3EV

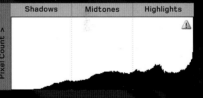

Combined histogram

Shadows	Midtones	Highlights

Exposure spacing

Although there is no hard and fast rule about how far apart you should space the individual exposures in a bracketed sequence, there are some benefits to shooting a sequence with a spacing of 1EV rather than 2EV.

To explain this point, here's another sequence of images, ranging from -3EV to +3EV, taken at 1EV increments. As you can see from the histograms for the lightest and darkest images, the sequence more than covers the dynamic range of this scene, but how many of these shots are strictly necessary, and what would be the optimal EV spacing for a sequence of images covering this EV range?

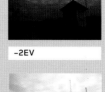
-3EV

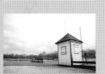
-2EV

-1EV

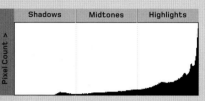

Metered exposure +1EV +2EV +3EV

Histogram for the darkest image

Histogram for the lightest image

To answer this, the following tone mapped images were created within Photomatix Pro. All four versions were created using the most extreme settings within Photomatix Pro to emphasize any differences, although it should be noted that these extreme settings will inevitably introduce some noise into the tone mapped image irrespective of any other factors.

As you can see, there isn't a huge difference between the images constructed using a 1EV spacing (in both the five shot and seven shot sequences), but both of the three-shot sequences are noticeably degraded, especially the one constructed using the ±3EV images from the sequence. Put simply, shooting a sequence using a smaller EV interval between the different exposures will minimize the noise in your final image, and ultimately produce a better result.

▶ Detail of image constructed using three images from the original sequence: -2EV, the metered exposure, and +2EV

▶▶ Detail of image constructed using three images from the original sequence: -3EV, the metered exposure, and +3EV

▶ Detail of image constructed from five images: -2 EV, -1EV, the metered exposure, +1EV, and +2EV

▶▶ Detail of image constructed using all seven images from the original sequence

Alignment

As well as making sure that you shoot enough images to cover the entire dynamic range of the original scene, the content of each frame ideally needs to be identical to the other frames in the sequence, especially in terms of alignment. In these three images of a small hut beside a lake, the position of the camera changed slightly with each exposure. The difference isn't huge, but the tone mapped result, created from these three images is totally unacceptable due to the misalignment of the various elements.

Fortunately, all of the programs we will be looking at in this book offer ways in which such misalignments can be corrected. They all operate in a similar fashion; comparing the content of each frame as the initial HDR image is created, and adjusting the perspective, rotation, and scale so the sequential image are aligned as accurately as possible. In a second tone mapped version of the hut, the source images were aligned using Photomatix Pro, and there are now no traces of the original misalignment.

However, while most HDR generators will do a good job of correcting alignment problems, you should still aim to avoid this problem when you shoot your initial sequence. This is because each image in a sequence needs to be moved relative to the other frames to correct the misalignment, and the various adjustments will invariably mean that your final HDR image will need to be cropped.

If the misalignment between the frames is minor, the amount of the image you will lose won't be especially large. For this hut image, the amount of cropping required isn't too great, as indicated by the red crop box, but if the misalignment is higher you may find that the crop needs to be heavier, and this can be more of a problem.

-2EV

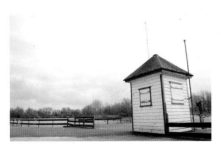

Metered exposure

+2EV

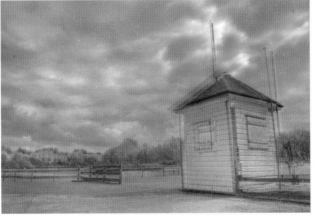

The result of misaligning the source images

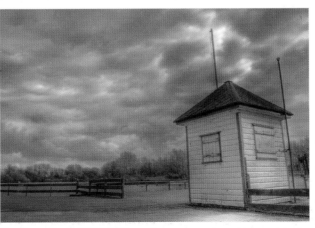

The alignment-corrected image

The cropped image

Ghosting

While alignment problems are caused by your camera moving between exposures, ghosting is caused by objects in the scene moving while you make your sequence of exposures. In the hut image, for example, there is a bird in flight, which appears in the top-right corner of the frame. Because the bird changed position while I shot the initial seven-shot sequence, it appears in the final tone mapped images as a "ghost."

Ghosting is harder to correct than misalignment, and only one of the three HDR programs we will be discussing offers a reliable way of automatically correcting the problem. Therefore, you are much better off avoiding it from the outset, and there are two ways in which this can be achieved—the simplest, and most obvious, is to avoid shooting scenes that contain any movement.

Often, this might not be possible, or you might simply not notice that something moved, like the bird in this image.

However, if you know that something moved—or suspect something *might* have moved—the answer is to shoot more than one sequence of images. This will give you a range of images to choose from at each exposure setting in the sequence, rather than being limited to one set of images. When you come to construct your HDR image you can choose those images where the movement is either absent or minimal.

When even this isn't possible, there are still ways in which ghosting can be removed, although as this can often be a time-consuming process, it's much better to avoid the problem whenever possible.

CHECKLIST: Shooting for HDR

Use a tripod	Although most HDR programs include an automatic method of aligning multiple exposures, they aren't always reliable, so it's a good idea to shoot your original sequence using a tripod. Take care not to move the camera between shots and, if you have one, use a remote release or your camera's self-timer.
Number of exposures	For the best results, you should shoot a minimum of three exposures, making sure the sequence covers the entire dynamic range of the scene—your darkest image should contain no blown highlights and your lightest should contain no blocked shadows. The easiest way to evaluate the dynamic range of a scene is to use a spot meter to measure the brightest and darkest areas, and calculate your exposure sequence accordingly. If you don't have a spot meter you can use your histogram to determine your start and end exposures.
Exposure spacing	There is no hard and fast rule about how far apart you should space the individual exposures in a bracketed sequence, but an increment of one to two stops is recommended. Differences of less than one stop needlessly replicate data, while increments greater than two stops risks a loss of data.
Auto-bracketing	Most cameras allow you to shoot an automatic sequence of three bracketed exposures, although some high-end DSLRs allow more. If the dynamic range of the scene can be captured within three shots, you should use this function to minimize the chance of misaligned images, rather than manually altering your camera's settings.
Manual bracketing	If you need to change your camera's settings manually, use the shutter speed or your camera's exposure compensation feature. Don't adjust the aperture as this will change the depth of field and create alignment problems.
Shoot quickly	If the scene you are recording doesn't contain any moving components then the speed at which you take your bracketed exposures doesn't matter. However, if the scene contains rapidly moving components such as people, birds, vehicles, and so on, these cannot be recorded—at least not reliably. With scenes containing slow-moving elements such as clouds, the faster you shoot the more likely they are to be in much the same place throughout the sequence.
Exposing for the shadow detail	The two most important shots within a bracketed sequence shot specifically for HDR, are the lightest and the darkest. The darkest shot is relatively straightforward—you just need to make sure that you haven't blown the highlights—but the lightest shot is a bit trickier. Make sure that the histogram contains some space at its leftmost edge to capture the full range of shadow detail.

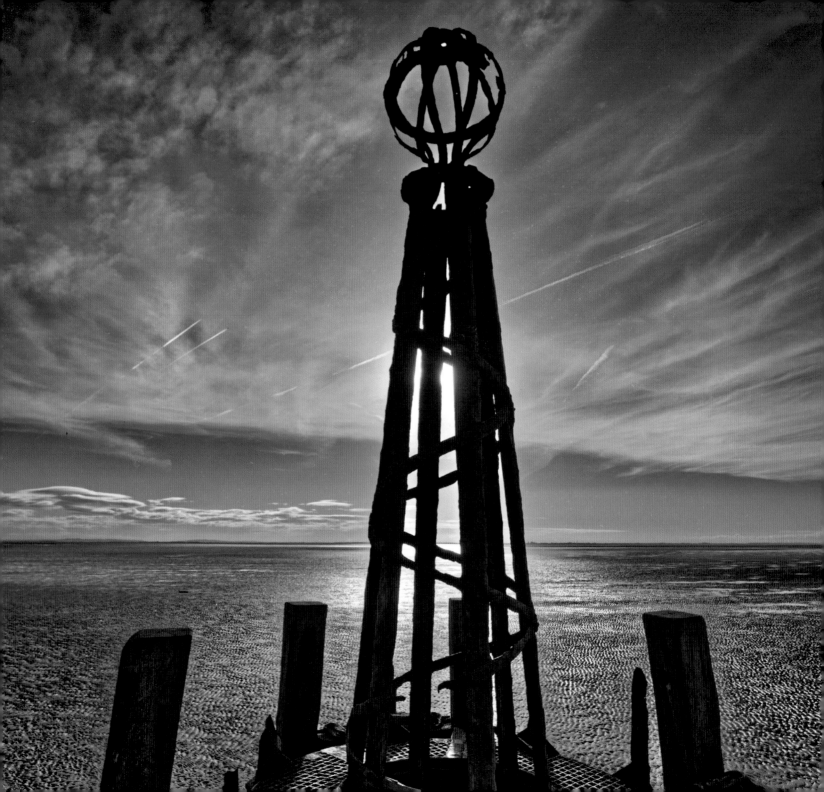

Chapter 3:

Merging Your Bracketed Sequence

HDR Software: The Options

As I mentioned in the introduction, while the history of HDR photography can be traced back to the exposure-blending techniques developed by Gustave Le Gray in the 1850s, it wasn't until earlier this century that HDR software became more widely available to photographers; Photomatix was first released in 2003, followed by FDRTools in 2004, and it wasn't until 2005 that even the most basic HDR functionality was added to Photoshop.

A few years down the line and Photomatix Pro has reached version 3, FDRTools Advanced is at version 2, and Adobe has added some additional functionality to its HDR processing with Photoshop CS4. In addition, there is now a range of other programs available, such as pfstools (a command line tool), easyHDR, Hydra, and Dynamic-PHOTO HDR. What all these programs share is their ability to combine a bracketed sequence of exposures into a single 32-bit HDR image, and tone map it into a 16-bit or 8-bit LDR image that can be viewed or printed on a range of traditional devices. However, the way in which each program accomplishes these tasks is quite different, and each provides a varying degree of functionality at each stage of the process.

It would be great if I could now tell you that I am going to take a detailed look at all the different programs that are available to you, but rather than provide a short summary of each it is far more useful to take a more detailed look at the three most established programs; Adobe Photoshop, Photomatix Pro, and FDRTools Advanced. All three are available for Mac and PC, all three have their strengths, and all three can be used to create stunning images that are simply not possible by any other means.

In addition to their strengths, it's equally important to be aware that they all have their weaknesses, and all three do some things slightly less well than the others. I will cover these in more detail in subsequent chapters. In this section I will provide an overview of the features they share and how they differ, in terms of how they can be used to both generate and tone map your images.

If you have read any other books on HDR imaging, you might have noticed that most of them often contain a side-by-side visual comparison from two or more programs, showing the same HDR image processed using different software. I'm going to avoid this, because I don't feel it is especially helpful, for two significant reasons. The first is that working with HDR images is a two-stage process that involves generating an HDR image that you subsequently tone map. As HDR images cannot be viewed on conventional devices prior to tone mapping, this stage of the process can't be illustrated on the printed page, or on most computer screens, so comparisons between different programs at the HDR generation stage are wholly redundant.

The second, equally significant reason is that each of these program works well in some circumstances but not others. For example, if the original sequence of images contains any motion, Photoshop will often produce results that are close to useless, simply because it has no algorithms for reconciling the differences between the individual frames, either when the initial HDR image is created, or when it is tone mapped. Photomatix Pro, on the other hand, will do a better job, and it's often the case that FDRTools will deliver the

best result of the three. By the same token, Photomatix Pro can often produce the most interesting results overall, but it can have problems controlling the evenness of the lighting, and can introduce halos around objects that are placed against a lighter background. Both Photoshop and FDRTools, on the other hand, often perform better in these situations, so any direct comparison based on how each of these programs converts a single sequence of images is likely to be misleading rather than informative; it will only illustrate the common ground they share rather than exemplifying their strengths. The bottom line is every image sequence is different, and no one program will deliver the "best" result in all situations.

So, we need to accept from the outset that each of the programs discussed has its strengths and weaknesses. While Photomatix Pro is perhaps the best all-rounder, both FDRTools and Photoshop will produce better results in some circumstances, so the choice of which program you should use will depend on a variety of factors. These include the style of HDR image you wish to produce, the nature of the original scene, the extent to which there is movement within and between exposures, and so on. For this reason I would definitely recommend that you add Photomatix Pro and FDRTools to your HDR toolbox, and would suggest that you try out Photoshop as well. Fortunately, all three program allow you to download a free demo version, so you can try each one out before you buy.

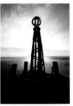

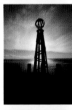

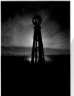

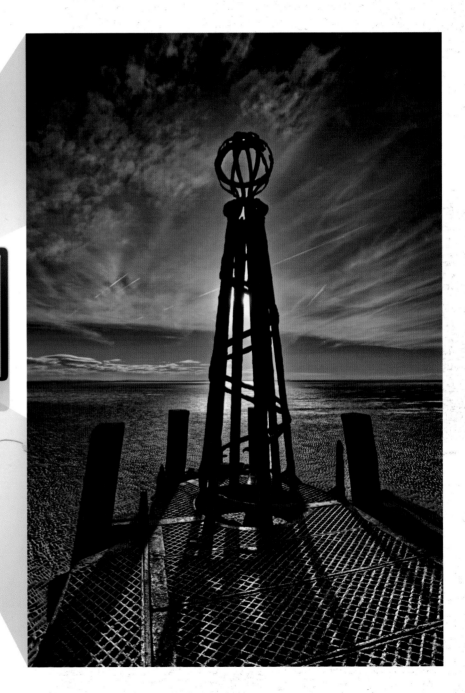

The principal of an HDR program is simple: it takes a sequence of images made at different exposures and combines them to produce a single photograph.

Adobe Photoshop

If you don't already have a copy of Photoshop, then I wouldn't recommend purchasing it simply to produce HDR images: not only is it very expensive, but it's also the least capable of the three programs examined here. That said, if you own a copy of Photoshop CS2 or above you will definitely find its Merge to HDR function useful in some circumstances, but it is not something you will perhaps want to rely on for every HDR image your create. As you will see, both Photomatix Pro and FDRTools give considerably more control, both in terms of generating an initial HDR image, and its subsequent tone mapping.

However, Photoshop does have some features that are useful, and in terms of producing an initial HDR image, Photoshop is the only program here that allows you to modify your Raw files prior to constructing the HDR image. On first inspection, Photoshop also appears to offer a better range of tone mapping operators than Photomatix or FDRTools, providing four separate methods—Local Adaptation, Exposure and Gamma, Equalize Histogram, and Highlight Compression—for you to use. FDRTools, by way of comparison, offers only three, while Photomatix Pro has just two tone mapping options. Unfortunately, only Photoshop's Local Adaptation and Exposure and Gamma methods are useful for photography, and only the Local Adaptation method offers anything beyond very basic control over the appearance of the tone mapped image. Its biggest strength though, is its capacity to produce photo-realistic images from an exposure sequence with a high EV range, as you will see in the next chapter. Its biggest weaknesses are its lack of features and the absence of any fine scale control over both the creation of the initial HDR image and its tone mapping. So, while it does have its benefits, these only apply to a very limited range of circumstances.

Using Photoshop to generate a 32-bit HDR file

Creating a 32-bit HDR file in Photoshop is a relatively straightforward process that you can initiate from the file menu (File>Automate>Merge to HDR) (pic A). This will present you with a dialog box that lets you select the images you want to work with (pic B). The most efficient way to do this is to use the Browse button to navigate to the images, but you can also open the files first then use the Add Open Files button. If you're using a computer with a large amount of RAM (in excess of 4GB) then this second option works well, but as the process of generating the HDR file is very processor-intensive I would recommend the Browse option. Once you have selected your images, you can press OK and wait for Photoshop to create the HDR image.

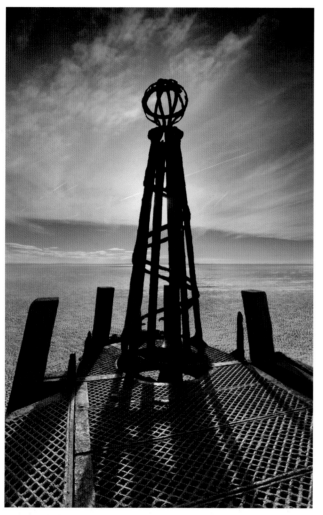

Although this image was created using Photoshop, it is not a "true" HDR image. Instead, it's a combination of three exposures, using gradients and masks to blend the best bits from each image manually. This is something that can only be done in an editing program, and in this instance gave a superior result to Photoshop's Merge to HDR tool.

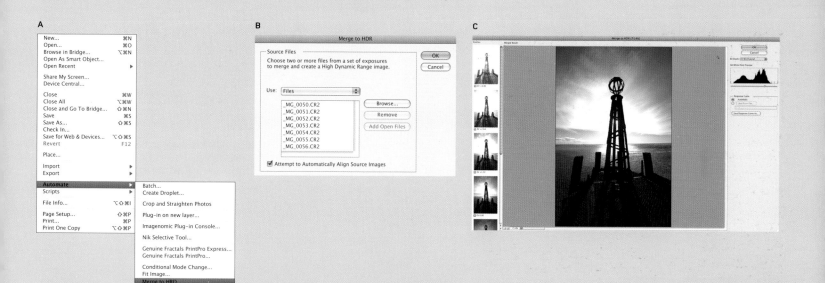

At this stage, if you are working with a large number of originals and don't have a powerful computer, you might want to go and put the kettle on, as it can take some time for Photoshop to generate the 32–bit HDR. Once the process is complete, you will be presented with another dialog box (*pic C*).

There are three options for you at this stage. First, you can deselect any of the original images by using the checkbox below each preview image. Second, you can set the bit-depth of the generated file. If you want the file to contain all the original image data you need to leave this set to 32 Bit/Channel. Finally, you can adjust the White Point Preview. By moving the slider beneath the histogram, the White Point Preview adjusts the appearance of the preview image, which isn't especially useful—it just changes the on-screen preview, not the file itself. However, it does give you an idea of the range of information that has been encapsulated within the 32-bit image.

If you click the OK button, Photoshop will generate the 32-bit HDR image, and the next step is to convert this into an LDR image that you can subsequently post-process. Before you convert to LDR you should save your HDR file, and there is a wide range of file formats you can use—Photoshop, Large Document Format, OpenEXR, Portable Bit Map, Radiance, and TIFF. If you will be using Photoshop to convert your image to LDR then you should use the Photoshop format as it generates the smallest files, but if you're going to use an alternative HDR program you should choose the OpenEXR format.

The original sequence of images

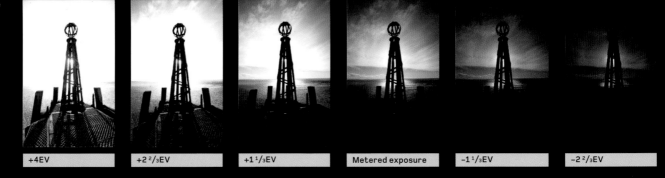

| +4EV | +2 2/3EV | +1 1/3EV | Metered exposure | −1 1/3EV | −2 2/3EV |

Final image detail

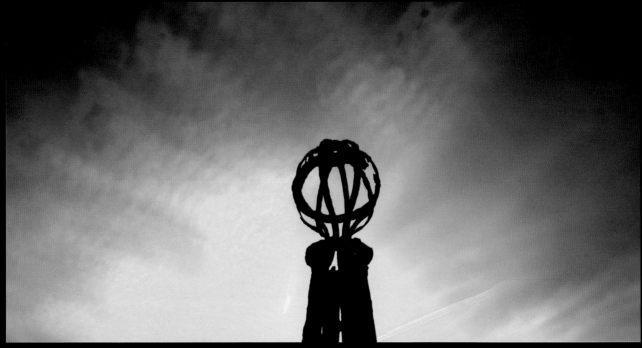

When not to use Photoshop

The biggest problem using Photoshop to generate your HDR images is that it cannot correct for movement between exposures. For example, the sequence shown here was taken on a very windy day. While the movement of the clouds isn't obvious when you take a look at the sequence, it is very noticeable in a detail taken from the final image; the clouds are banded and there are a variety of obvious color and luminosity artifacts in the sky.

The benefits of using Photoshop

While Photoshop is clearly not the best choice for sequences of images that contain movement, it does have one major advantage over the other options we will be discussing—Raw processing. For the best results, you should always work with Raw files rather than TIFFs or JPEGs, as this will keep as much data in your HDR image as possible. Yet while other programs will let you open a range of Raw files, they don't let you edit them before you combine them into an HDR image. With Photoshop, you can make a variety of alterations using Camera Raw, before running the Merge to HDR command. For example, you can change the white balance, clarity, saturation, noise reduction, and so on, so any change

that you could normally apply using Camera Raw can also be applied to your bracketed sequence of images.

To do this you first need to open the full sequence of images in Camera Raw. This will bring up the Camera RAW dialog with your sequence of images arranged down the left hand side (*pic A*).

If you want to make a change to the entire sequence, you need to select one of the images, and it's often easier to preview the changes you're going to make if you select the metered exposure. Then, click Select All at the top-left of the dialog, and any changes you make in Camera Raw will be applied to all of the images in the sequence (*pic B*).

At this stage you can click the Open Images button, and then use the Add Open Files option after initiating the Merge to HDR command, or click the Done button. If you choose the latter option the changes you specified within Camera RAW will be applied when you combine the images.

A

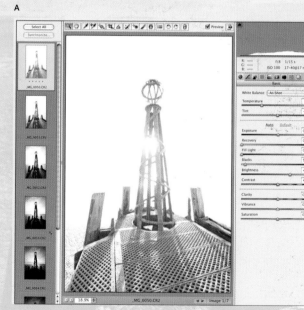

B

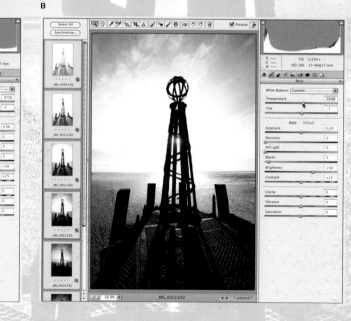

This HDR image was
tone mapped using
Photomatix Pro's

Details Enhancer
to produce a
hyper-real result.

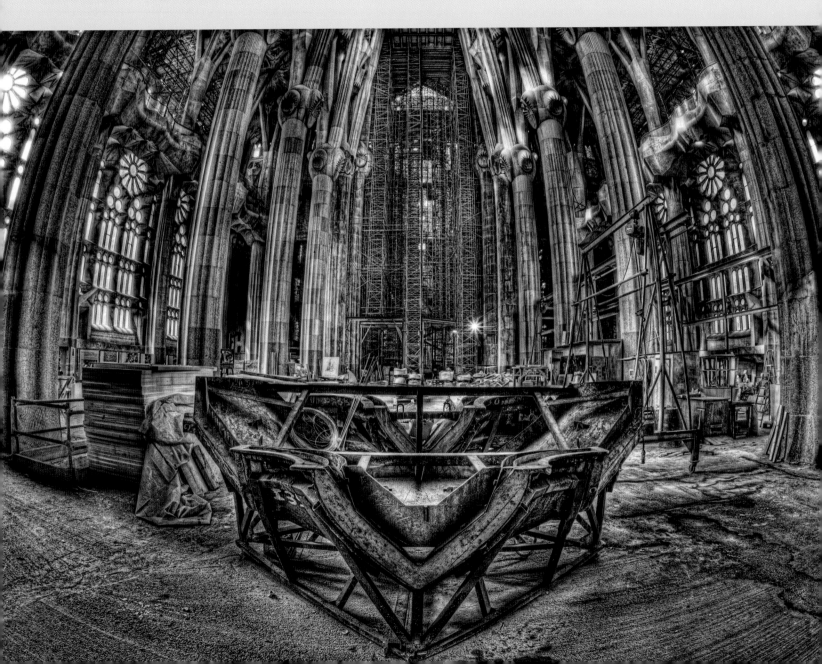

Photomatix Pro

If I had to choose one program to create and process all my HDR images, it would have to be Photomatix Pro, not least because it's the most configurable and flexible program here. In terms of creating your initial HDR images, it doesn't offer quite as much control as FDRTools, but it does offer a variety of ways to align your images and remove any motion artifacts from your tone mapped images.

However, its real strength lies in its sophisticated tone mapping algorithms, even though it only offers two options: the Tone Compressor and the Details Enhancer. The Tone Compressor is the simpler of the two, and can be used to produce results that are similar to those that can be obtained with Photoshop, but unlike Photoshop it lets you to change seven different parameters to construct your final image (FDRTools offers five parameters).

As we will see, the Details Enhancer method is considerably more sophisticated, and can be used to produce both photo-realistic and hyper-real images thanks to 15 different sliders and controls that enable you to fine-tune the appearance of your tone mapped images. Because of its sophistication, adjusting an image using the Details Enhancer can often be a time-consuming process, but the results are often considerably more impressive than those that can be achieved using either Photoshop or FDRTools.

Using Photomatix Pro to generate a 32-bit HDR file

As with Photoshop, generating a 32-bit HDR file using Photomatix Pro is a relatively straightforward process. If you select Generate HDR from the Process menu (*pic A*) you will be presented with a dialog similar to the one in Photoshop (*pic B*). All you then need to do is browse to your source files, or drag and drop them onto the dialog, after which you can click the OK button. Once the images are loaded you will be presented with another dialog (*pic C*).

At this stage you have a variety of decisions to make. The first relates to aligning the source images, and even if you have shot your bracketed sequence on a tripod it's a good idea to leave this selected, not least because even minor vibrations can misalign your images. You have two alignment choices—"By correcting horizontal and vertical shifts" and "By matching features." Generally, I use the first option, only switching to the second if Photomatix Pro doesn't do a good job. If your images were misaligned when you shot them, and Photomatix Pro has moved the images relative to one another, it will also crop your image automatically to remove the surplus detail at the edges of the frame. If, for any reason, you don't want it to do this you can click the Don't Crop button.

Second, you can request that Photomatix Pro attempt to remove "ghosting artifacts" from your image—moving people, objects, and so on. As this is a relatively processor-intensive task you can leave this turned off if you are confident there are no moving elements in the original sequence of shots. I should also add that while both options work well, they won't perform miracles, so it is worth attempting to take your shots when movement within the scene is at a minimum. For example, if we take a look at how Photomatix Pro performs using the same set of images we used to demonstrate Photoshop's Merge to HDR command, and use the Background Movement algorithm to reduce the ghosting artifacts, we can see that while some of the odd artifacts that we saw in the Photoshop version aren't evident, the clouds still look unnatural (*pic A*).

The next set of choices is grayed out, as they only apply if your original images are TIFF or JPEG files. Generally, I would always recommend that you use Raw files, and not worry about these settings, but if your camera can't shoot Raw, you may find these options useful. Finally, you can adjust the white balance of the generated HDR by using one of a number of presets, or by entering a custom value. You can also change the "color primaries" to reflect your destination color space, and after making these choices you can click the OK button to generate your 32-bit HDR file. Save this using as either a Radiance RGBE or OpenEXR format file.

When your HDR file opens, you will see that unlike Photoshop's rather crude White Point Preview, Photomatix Pro has an HDR Viewer. This is a small preview window that shows the detail in an area of the image you roll your mouse over. The accompanying examples illustrate how this works in practice, clearly showing the detail in both the darkest and lightest areas of the image when the cursor is over them (*pic B* and *C*). This is really helpful when it comes to previewing areas in an image that might contain movement artifacts, as rather than going through the process of converting the HDR image, only to find out that there are issues with movement, you can check the preview and start over using different settings if you discover any problems.

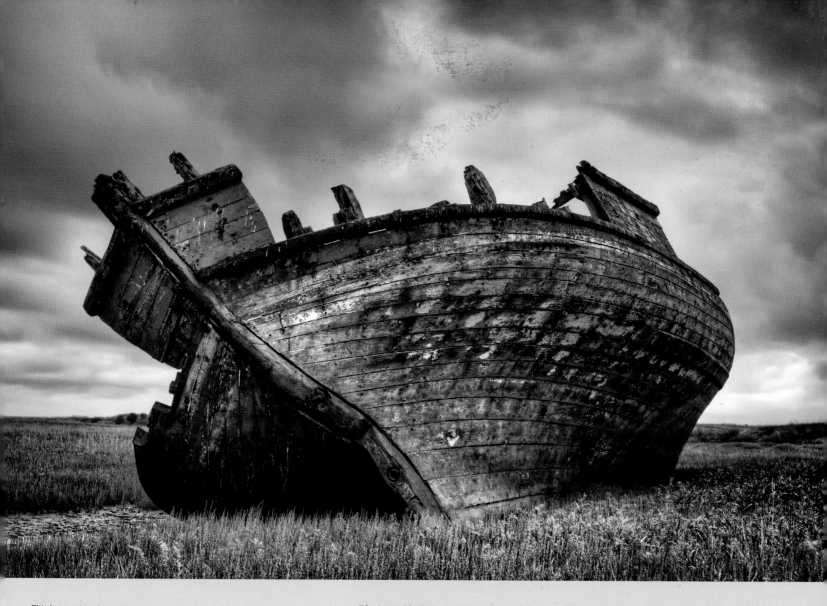

This low contrast scene was enhanced using Photomatix Pro's tone mapping tools.

Photomatix Pro: Strengths and Weaknesses

Compared to Photoshop, Photomatix Pro has two main strengths; it will attempt to reduce motion artifacts from a bracketed sequence of shots, and it's much faster at converting a bracketed sequence of images into an HDR image. If you have a powerful computer, this may not be an especially important factor, but for less powerful machines the difference in processing times can be significant.

The downside to using Photomatix Pro is that you have very limited control over how you can interact with your Raw files. Other than adjusting the white balance, all you can do to a Raw file is open it prior to producing your HDR image.

FDRTools

Developed by Andreas Schömann and AGS Technik, FDRTools offers considerably more control than Photoshop when it comes to generating your initial HDR image and its subsequent tone mapping. It also offers the most control over how your initial images will be combined into the final tone mapped image. This is a topic we will be discussing in a lot more detail, but at this point it's worth pointing out that FDRTools allows almost pixel level control of how your bracketed sequence of images will be combined. It is this level of fine-scale control that means FDRTools is often the best choice when there is movement between the individual frames in your exposure sequence. However, in terms of tone mapping your images, FDRTools is not as configurable as Photomatix Pro. Of its three tone mapping operators (Simplex, Receptor, and Compressor) the Compressor method is the most useful and, as you will see in the next chapter, this is ideally suited to producing photo-realistic results.

Creating a 32-bit HDR image using FDRTools Advanced

On first inspection, FDRTools Advanced can seem confusing, not least because the Mac and PC versions have their own, unique GUI (Graphical User Interface), but despite this, it is still an extremely capable piece of software. One of its greatest strengths is that it allows you to switch between generating your HDR image and tone mapping it. With Photoshop and Photomatix Pro, creating an HDR image is the first step, after which the image is tone mapped in a linear workflow pattern. With FDRTools, the two processes are carried out simultaneously, using an HDR Image Inspector window (which you can use to preview your HDR image), and a Tone Mapped Image window where you preview the final image. As you work with your image(s) you can switch between the windows, so you can make changes to the tone mapping settings, then return to the HDR settings, then back to fine-tune the tone mapping settings, and so on (pic A).

A

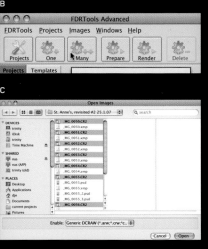

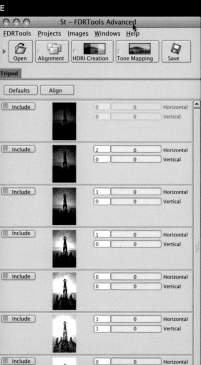

As with all HDR programs, to begin the process you first need to generate your HDR image. You can do this by either dragging and dropping your source images onto the program's icon, or by opening FDRTools and using the Many button (*pic B*) at the top of the main dialog. This will open a system dialog that you can use to browse to your source files (*pic C*), and the selected images will load into a "project" that you can name and save to work on at a later date (*pic D*).

Next, you need to click the Edit button. After a short delay, this will bring up the main dialog for the selected project (*pic E*). This dialog has five tabs: Open, Alignment (the active tab when the dialog first opens), HDRI Creation, Tone Mapping (which we will return to in chapter four), and Save.

The first step (Alignment) involves aligning your images, which you can do by clicking the Align button immediately above the image sequence. This applies both a horizontal and vertical shift to all but the first image in the sequence. As the accompanying illustration shows, even though this sequence was shot using a sturdy tripod and a remote release, there is still a small amount of movement between the frames, indicated by the numbers next to each exposure (*pic F*).

Once you have aligned your sequence you can move on to the HDRI Creation tab. This dialog may appear confusing initially as there are a lot of options to choose from (pic A), but at this stage we are going to concentrate on just two of the main methods of creating an HDR image: the Average and Separation methods.

The Average method, as you can see from the dialog (pic B), is best suited to images with no movement between the frames. If we use this algorithm to generate an image from the sequence used previously we will see that it encounters exactly the same problem as Photoshop and Photomatix Pro, with obvious movement artifacts in the sky (pic C).

However, if we switch to using the Separation method, the movement artifacts in the clouds have been virtually eliminated (pic E). This is because the Separation method (pic D) determines each pixel in the final image from a single source image, rather than averaging out the values from the full range of images. The net result of this is motion artifacts—whether they are caused by scudding clouds, moving people or vehicles, or anything else within an image that moves between frames— are minimized.

In addition to the Average and Separation methods, FDRTools offers two further ways that you can combine your images: the Creative method and the xDOF

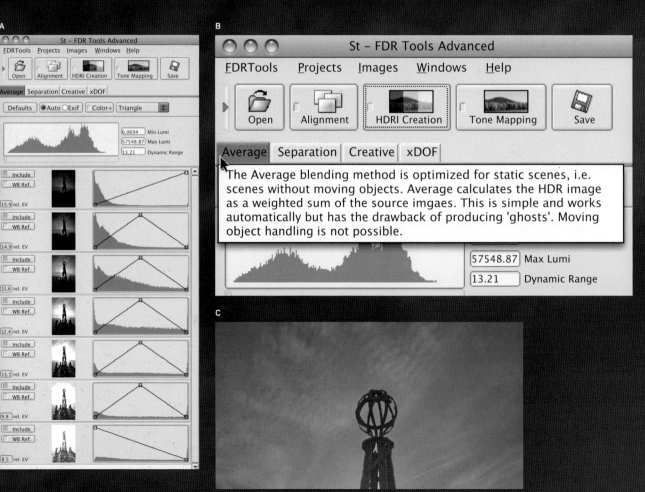

method. The Creative system was created to allow you to blend images with differing content, so you can use a sequence of images photographed at different apertures, under different lighting, or even containing different content. While less useful than the Average and Separation methods, this does open up a range of creative possibilities—hence the name.

The xDOF function is not an HDR merging technique, but it does allow you to combine a sequence of images. In this instance, images taken at different focus settings are used to create a final image. So, rather than extending the dynamic range, it produces a final picture with a larger depth of field—useful for macro photography, or for creating images with an apparently "infinite" depth of field.

As with Photoshop, FDRTools also allows you to exclude any of the images you initially loaded, and this is done using the Include button to the left of each image

(*pic F*). This can be useful if, for example, you have taken a seven-shot sequence and there is some particularly violent movement in one of the frames that FDRTools can't eradicate. Simply removing the relevant image may correct the problem. You should be careful not to remove either the lightest or darkest exposure, though, as this can compromise the quality of your final HDR image by introducing clipped highlights, blocked shadows, or an increase in the amount of noise in the image.

D

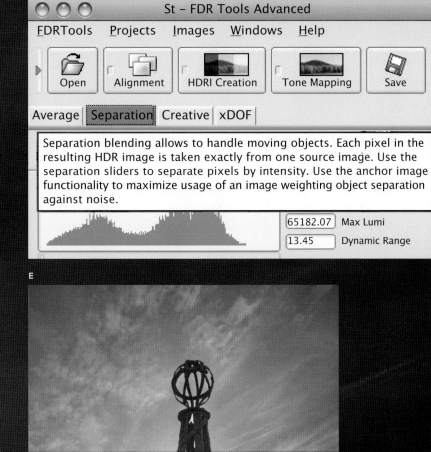

F

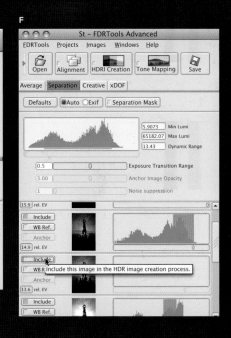

E

Strengths and weaknesses

As you have just seen, FDRTools greatest strength is its ability to eradicate movement artifacts. This isn't guaranteed to be entirely successful—especially if the movement is particularly pronounced—but it does a significantly better job than either Photoshop or Photomatix Pro. And, like Photomatix Pro, it can also produce an HDR image in a fraction of the time it takes Photoshop to perform the task.

In terms of its limitations, it offers very little control over your original Raw files—even less so than Photomatix Pro. While you can adjust the white balance, this can only be done by choosing one of the original images in the sequence as a reference point, rather than making a manual adjustment or specifying a white balance setting yourself.

Which program should you use?

At this stage, it's worth pointing out that we have only just begun our discussion on these three programs. We have seen three different methods of creating an HDR image, but this still needs to be converted from a 32-bit image back into a 16-bit or 8-bit LDR image that we can view on screen or print out. Each of the programs has its merits, and each can be used to good effect, but as I said at the outset, your final decision should be based on which program will produce the best results for a particular sequence of images—there is no single solution.

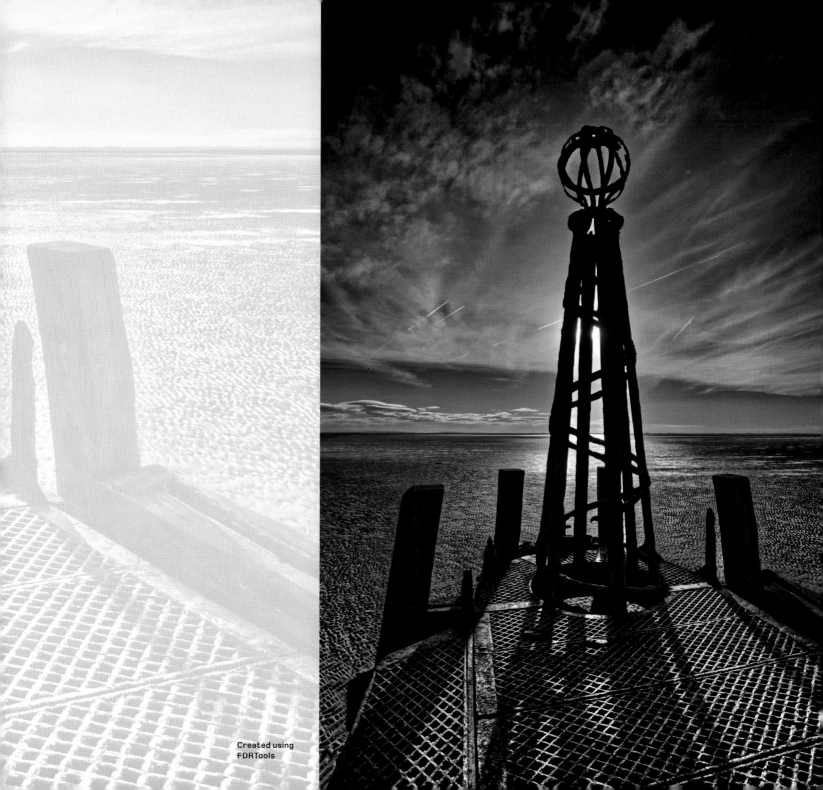

Created using
FDRTools

Chapter 4:
Creating Photo-Realistic Images

Photorealism and HDR Photography

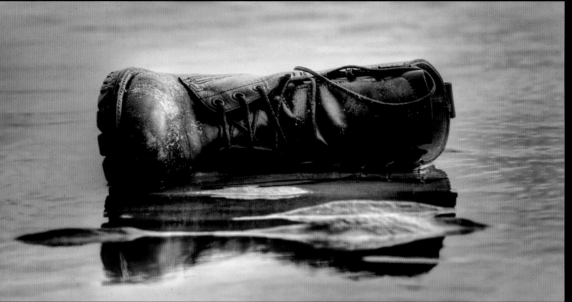

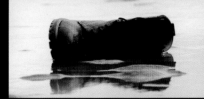

A single exposure

A tone mapped version
of the same subject

So far, our discussion of HDR imaging techniques has been a largely technical one, but there is also a variety of aesthetic considerations to consider. Perhaps the most significant of these concerns the style of HDR images you want to produce. The majority of HDR techniques were developed to overcome a particular technical problem—the dynamic range of a scene exceeding the dynamic range of a camera's sensor—and, related to this, HDR techniques let you manipulate the tonal range of a scene so the end result can look more

natural than an original photograph. If you take a look at the images of the abandoned boot, for example, the tone mapped version looks more realistic than the straight exposure, with an appreciably greater range of tones in the darker areas (detail that is almost lost in the straight shot), and a tonal range in the water and sand that seems more natural and more closely resembles our perception of the world. This type of HDR result is often referred to as "photo-realistic" HDR.

More recently, however, the term HDR has become almost synonymous with a particular style of tone mapping that is often used to produce images that are almost "cartoon-like" or illustrative in nature—images that look more like paintings or computer generated images than anything you might stumble across in the real world. In the remainder of this book I will refer to this style of HDR image as "hyper-real," in that this type of image goes beyond the appearance of reality.

So, on the one hand, we can consider HDR techniques as a method that can be used to produce a photo-realistic representation of a scene, while on the other, we can view it as a technique that can be employed to generate a more surreal interpretation of the same scene.

The key point here is that these radically different styles are generated using the exact same tools and procedures—they are just applied in different ways. In both cases, you need to shoot a bracketed sequence of exposures and generate an HDR image, and in both cases you need to tone map the HDR image to produce an LDR version that can be printed and displayed. Therefore, the difference between the two styles is not a technical one, but simply a function of the way you tone map your HDR image. One choice of settings will produce a more photo-realistic result, while more extreme settings will produce a hyper-real result, with myriad possibilities in between.

In this chapter we will concentrate on producing photo-realistic images, while the following chapter will focus on creating hyper-real HDR images. But it is important that these should be seen as extreme positions on the same continuum, and not mutually exclusive alternatives. You can aim to produce an image using either style, or a final picture that falls somewhere between the two. By the time you have worked through both chapters you will have a sufficiently detailed understanding of how to control the tone mapping process to suit your own creative and aesthetic aims.

A more illustrative, or "hyper-real" tone mapped image

Photoshop's HDR Options

The HDR preview image

Previewing the darker tones

Previewing the lighter tones

When you create or open an HDR image in Photoshop, the preview image contains a range of clipped highlights and shadows. This is because a typical computer monitor is an LDR (low dynamic range) device. In this example, the shadows appear to be clipped in the top-right hand corner of the image, and the sky between the buildings, at the bottom of the image, seems grossly overexposed.

At this stage, if you want to preview the range of tones contained within the original HDR image you can adjust the slider, at the bottom-left of the preview window. Dragging the slider to the left darkens the image, allowing you to preview the lighter tones in your HDR image, while dragging it to the right allows you to examine the darker areas. In both examples, you can see that the initial HDR contains a full range of tones, with no clipping at either extreme.

Having examined your 32-bit HDR image, the next step is to convert it into either a 16-bit or 8-bit LDR image. If you intend to do further post-production on your image, convert to 16-bit as this will provide an LDR image with considerably more data. To begin this process, change the bit depth of the image to either 16-bit or 8-bit via the Image>Mode menu.

Having chosen your output bit depth you will be presented with a dialog that allows you to select one of four conversion methods; Exposure and Gamma, Highlight Compression, Equalize Histogram, and Local Adaptation. Over the coming pages we will look at the Exposure and Gamma and Local Adaptation methods in more detail, but first we will take a quick look at the other two methods.

Highlight Compression

The Highlight Compression method is one of the simplest algorithms you can apply to an HDR image. It works by compressing the highlight details in the original 32-bit image to fit within the luminance range of a 16-bit or 8-bit file. This is an entirely automatic process, but it tends to produce a rather dark final image. As you can see from the example image, highlight detail is visible, but the shadow areas are still very dark.

Converted using the Highlight Compression method

Equalize Histogram

Photoshop's Equalize Histogram conversion method is also an automatic process, which works by compressing the entire dynamic range of the original HDR image, but attempts to retain contrast within the image in the process. On first inspection it appears to produce a slightly better result than Highlight Compression, adding some much needed detail to the shadow areas of the image. However, as you can see in this example, the histogram shows that it has clipped both the shadow and highlight detail, which defeats the purpose of shooting a range of exposures to capture the full dynamic range of the scene.

Converted using the Equalize Histogram method

Shadow and highlight clipping

Local Adaptation

Local Adaptation (as its name implies) is a method of constructing an LDR image that attempts to create local contrast within different areas of an image. In practice, this means that different areas within the image will each have a reasonably high tonal range in their own right, so a sky will have a reasonably distributed tonal range, as will the shadow areas of the image, the highlight areas, and so on. To illustrate this method I am going to use an HDR image constructed from six images.

Once you have created (or opened) the HDR file and initiated the conversion process using the Local Adaptation method, there are three settings you can change in the HDR Conversion dialog: Radius, Threshold, and the Toning Curve.

 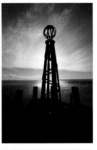 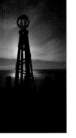 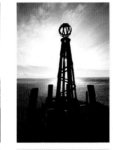

+4EV

+2 2/3EV

+1 1/3EV

Metered exposure

−1 1/3EV

−2 2/3EV

Radius and Threshold

Controlled by sliders, Radius controls the size of the local brightness region and Threshold specifies how far apart two pixels' tonal values must be before they're no longer considered part of the same brightness region. Together, they control the way that Photoshop determines which sections of the image should be altered, and which sections should contain a reasonably even tonal range.

Generally, the easiest way to determine which settings will work best is to adjust the sliders and consult the Preview. Be careful not to set too high a value for either setting as this can introduce halos around objects within the image. While this is something that can be fixed subsequently in Photoshop, it's much better to try and avoid it in the first place.

For most HDR images, the default settings for both sliders will generally produce the best results, especially when there are hard edges in the original scene. But, as with every other technique in this book, it is worth spending some time experimenting with different values and settings to see for yourself what effect they have.

Radius: 16 Threshold: 3

Radius: 16 Threshold: 0.50

In this example, the default settings (Radius 16 and Threshold 0.50) produce the best result, with no haloing around the top of the structure.

Initial Local Adaptation options, using three control points on the Toning Curve to deepen shadows, darken midtones, and lighten the highlights.

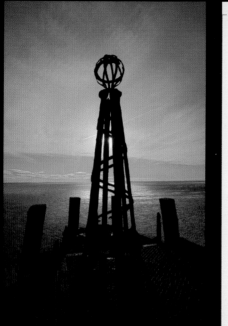

The Toning Curve

If the Toning Curve isn't visible, click the arrow to the left of *Toning Curve and Histogram*. You can then adjust the curve, which operates in much the same way as the standard Curves tool within Photoshop, with one important difference. At the bottom right of the dialog is an option labeled Corner. This lets you to set the control points on the curve as a corner rather than a point, which disables the equalization process, providing a linear tonal response between two points.

In this example I have set all three control points on the curve in this way, but the changes are relatively minor. The first control point (bottom-left) deepens the shadows, while the second (in the middle of the "curve") decreases the luminosity in the mid-tones. The third control point (upper right) marginally increases the luminosity of the highlight areas. These control points were all added by simply clicking on the curve, to produce a fairly natural-looking image.

If you're not familiar with using Curves, you might find this stage difficult, but there are no hard and fast rules about how to use this Curve, or how many control points you should use—this is more about the aesthetics of the image than any technical considerations. For example, if you wanted to produce a lighter version, with more detail in the shadow areas of the final image, you could alter the Curve accordingly, as shown here.

Alternate settings for the Toning Curve, producing more detail in the shadow areas.

Exposure and Gamma

Initially, Photoshop's Exposure and Gamma method of converting a 32-bit HDR image into an LDR image doesn't appear to be an especially good one, as it seems to produce images that look terrible. Often, they contain a variety of color casts, and the tonal range is much more restricted than those produced using the Local Adaptation method. However, with a bit of work, this method can produce LDR images that are strikingly different to those produced using other methods. The difference is hard to quantify, but images created using Exposure and Gamma can make their Local Adaptation counterparts appear quite clinical by comparison.

The starting point here is an eight shot sequence of the same structure used to illustrate the Local Adaptation method. As you can see, the HDR preview of the combined images contains a range of blown highlights and shadows. Converting this 32-bit file into an LDR image using Exposure and Gamma is a two-step conversion process, using just two sliders: Exposure and Gamma.

Adjust the exposure first, dragging the Exposure slider to the left until the brightest area of the image is sufficiently dark. In this instance a setting of -4.82 darkened the image until the overexposure around the sun had been reduced.

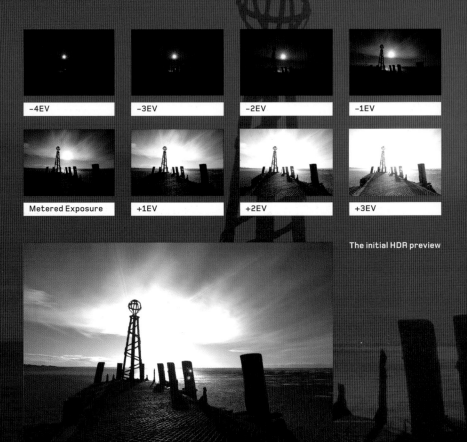

The initial HDR preview

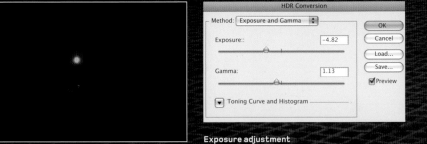

Exposure adjustment

Exposure and Gamma adjustment

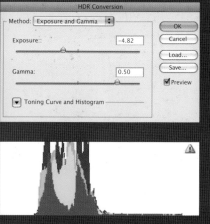

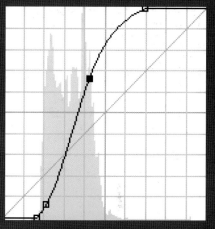

Clearly, the image is far too dark after the Exposure adjustment, so drag the Gamma slider to the right to lighten the overall tones within the image without affecting the brightest highlights. In this case I set the Gamma slider to 0.29.

At the moment, the image produced using the Exposure and Gamma method has little merit; it lacks contrast (so looks very dull), with the histogram showing that the majority of the tones are bunched toward the left.

The benefit of this technique isn't apparent until you make further changes to the image by adjusting the contrast of the LDR image during post-production. In this instance, once I had converted the image using the Exposure and Gamma settings above, I applied a very steep S-Curve in Photoshop to add some much-needed contrast.

The curves adjusted image

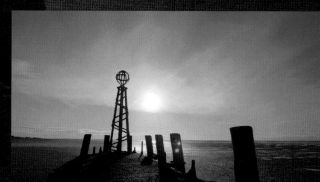

The curves-adjusted version looks far more natural, especially the way in which the clouds have been rendered. The overall quality of light seems better, and the lens flare—even though it is more obvious—looks less like a processing artifact, enhancing the impression that this is a "real" photograph, rather than an image created using an HDR technique.

There are downsides to this method though, starting with the need to create an LDR image that is very "flat" and

adjustments in Photoshop. As a guide, I would suggest you make sure the highlights aren't overexposed (by dragging the exposure slider to the left), and then adjust the Gamma so no parts of the image look too dark. Don't worry about how the image looks as a whole, just concentrate on the extremes.

The second downside—especially if you aren't overly familiar with Photoshop—is that you need to be reasonably proficient with the Curves tool to bring

Photomatix Pro's Tone Compressor

Photomatix Pro provides two ways of tone mapping an image—the Tone Compressor and the Details Enhancer. There is a third option (Exposure Blending), although as this doesn't involve generating a 32-bit HDR image it isn't, strictly speaking, a true HDR technique. We will take a closer look at the Details Enhancer in the next chapter, as this technique that can be used to produce very dramatic, hyper-real HDR images, and in this section we will focus on the Tone Compressor. The Tone Compressor is easier to use than the Details Enhancer, but it can be equally effective, especially if you are aiming to produce a photo-realistic result. To illustrate this, I am using an HDR file generated in Photomatix Pro from a sequence of six images.

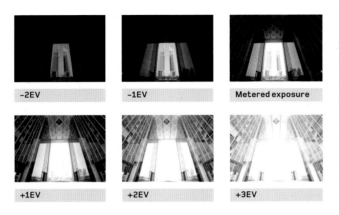

-2EV -1EV Metered exposure

+1EV +2EV +3EV

Once the HDR image is created, open it in Photomatix Pro and select Tone Mapping from the Process menu (Process>Tone Mapping). This brings up the Tone Mapping dialog and a preview window that shows how your 32-bit image will appear after you apply the settings. It's worth noting that the preview in Photomatix Pro is never entirely accurate as it is created in "real time," whereas the actual tone mapping process is a processor-intensive task that applies a complex set of algorithms. Generally speaking, though, the differences between the two are not major.

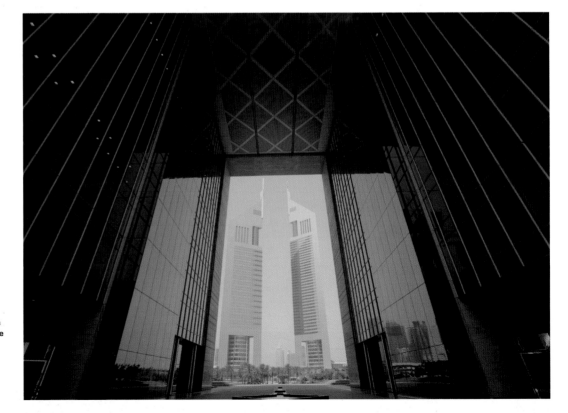

Photomatix Pro's default Tone Compressor settings produce an HDR image with plenty of detail in the shadow and highlight areas, but altering the various controls will make it even better.

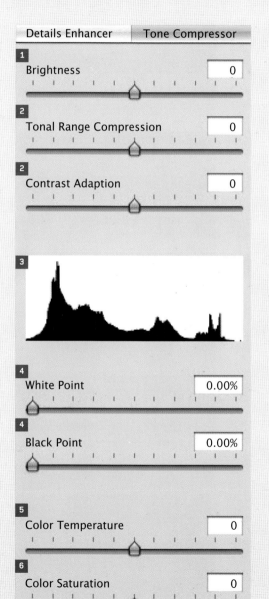

Tone Compressor dialog

When you choose Tone Compressor from the top of the Tone Mapping Settings window, you will be presented with a dialog that allows you to alter a variety of parameters. At first these will be unfamiliar, but with practise it becomes much easier to get the best from your HDR images.

1

Brightness This works in a similar fashion to the gamma (midtone) slider in Photoshop's Levels tool, affecting the overall brightness of the image without impacting too much on the white and black points. Sliding the Brightness slider to the left will darken the image, while sliding it to the right brightens it.

2

Tonal Range Compression and Contrast Adaptation These are the most important adjustments, which determine the local contrast and tonal range of the final image. If you use the default settings for both sliders, Photomatix Pro will produce an image with a full dynamic range, without clipping the shadows or highlights. They are explored in more detail on the next page.

3

Histogram Like Photoshop or your camera, Photomatix Pro's Tone Compressor histogram shows the distribution of tones in an image and shows if the highlight or shadow areas have been clipped.

4

White Point and Black Point White Point and Black Point work in much the same way as the white and black point sliders in Photoshop's Levels tool, allowing you to set the white (highlight) and black (shadow) levels in the image.

5

Color Temperature Color Temperature is similar to the color temperature adjustment in Adobe Camera Raw, allowing you to fine-tune the overall color to correct color casts in the image.

6

Color Saturation The most self-explanatory slider adjusts the overall intensity of the color in the HDR image.

Tonal Range Compression

According to the Photomatix Pro "help" file, Tonal Range Compression "controls how the tonal range of the 32-bit image is compressed into the 0-256 range of 8-bit monitors. The higher the value, the more both shadows and highlights will be shifted toward the center of the histogram."

In practice, decreasing the value (moving the slider to the left) will almost always lead to the image containing a large amount of clipped shadows.

If you drag the slider in the opposite direction to increase the value, both the shadow and highlight areas will become brighter, although the change is most noticeable in the shadow areas.

Contrast Adaptation

Photomatix Pro describes Contrast Adaptation as an option that "sets how much the contrast is adapted to the intensity of the pixel values processed."

I'm sure that this is technically correct, but it doesn't offer much assistance when it comes to actually creating an HDR image. So, put more simply, if you drag the slider to the left you decrease the value, and your histogram is extended more. Dark areas become darker, and light areas become lighter.

Conversely, if you shift the slider to the right, you increase the amount of Contrast Adaptation, which has the effect of compressing the histogram and creating a much flatter (lower contrast) image.

At this stage it's worth mentioning that every set of bracketed exposures you shoot will be different, and there are no "absolutes" when it comes to the optimum settings. Each HDR image you create will require you to spend some time trying out alternative options. Having determined the settings that you think work best for your particular image, click the Process button to generate your LDR image. Once the process is complete you simply need to save the file (File>Save As) as either a 16-bit or 8-bit TIFF or JPEG file. If you intend to do some subsequent work in Photoshop, save your image as a 16-bit TIFF to get the highest quality image, or, if you intend to email the image, or post it online, save it as an 8-bit JPEG file.

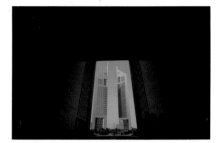

Tonal Rage Compression: –10

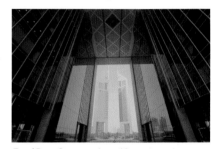

Tonal Rage Compression: +10

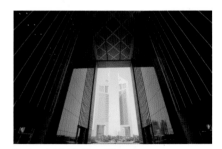

Contrast Adaptation: –10

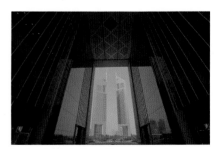

Contrast Adaptation: +10

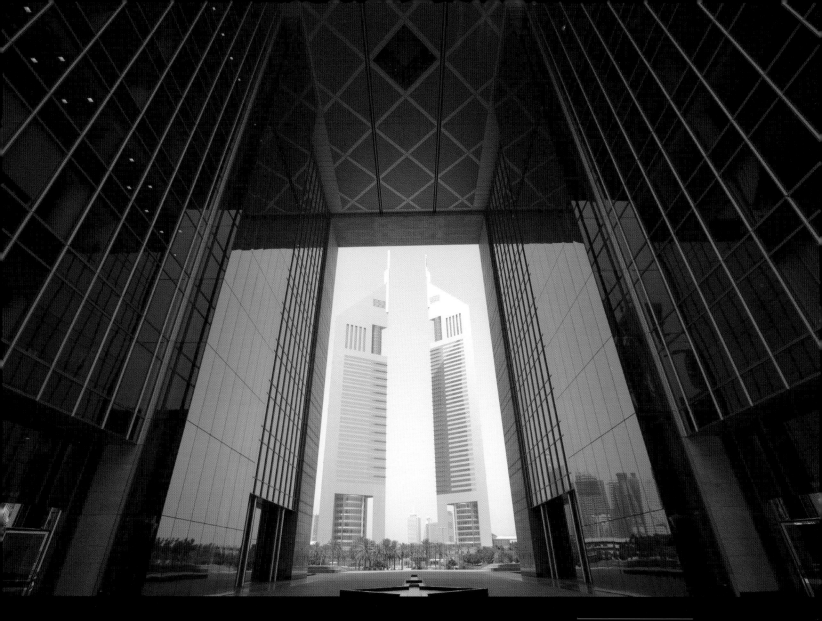

Tone Compressor settings

Brightness: –1
Tonal Range Compression: 1
Contrast Adaptation: 10
White Point: 2.90%
Black Point: 0.00%
Color Temperature: –2
Color Saturation: –4

FDRTools

In the previous chapter we looked at producing an HDR image using FDRTools, and in this section we see how you can use this program to tone map your images, concentrating on producing photo-realistic images. At the time of writing, there are two versions of FDRTools available—FDRTools Basic, and FDRTools Advanced. FDRTools Basic is currently free, and a good option if you want to try out some of the program's rudimentary functionality. However, it's worth noting that FDR Tools' major strength is its Compressor method of tone mapping an image, which is not available in the Basic version.

The seven-shot sequence I am using as a starting point was shot from the Madinat Jumeirah resort in Dubai, with the Burj Al-Arab in the background. The images were recorded with a 1EV spacing, but as you can see from these images, the dynamic range of the original scene isn't huge—the metered exposure contains some marginal shadow clipping, while the +1EV shot only just clips the highlights.

However, adjusting the exposure to get the best possible result in a single, "straight" shot doesn't do justice to the opulence and grandeur of the original scene—there's a fairly dull foreground, an absence of detail in the shadow areas, and a sky that looks pale and washed out. Some of these defects could be at least partially corrected in Photoshop, but FDRTools provides a solution that will allow a much more impressive final image, without the need for any complex post-processing.

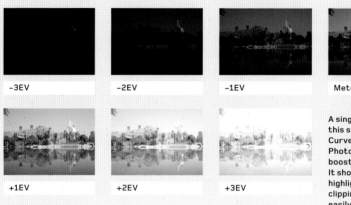

−3EV	−2EV

−1EV	Metered exposure

+1EV	+2EV	+3EV

A single exposure of this scene with a Curve applied in Photoshop to slightly boost the contrast. It shows minimal highlight and shadow clipping, and could easily be considered an "acceptable" photograph in its own right. However, shooting a sequence of images and combining them in FDRTools can produce a much better end result.

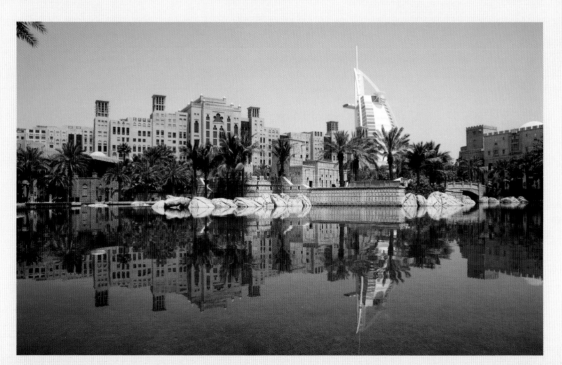

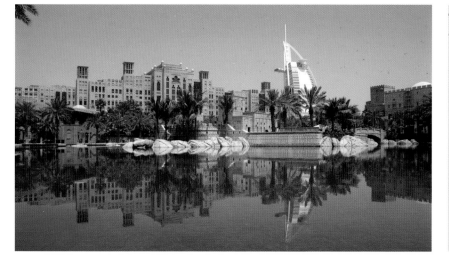

Working with FDRTools Advanced

After loading the image into FDRTools, excluding any from the HDR image, and aligning them if necessary (as described in Chapter 3), you are ready to begin the tone mapping process by clicking the Tone Mapping button in FDRTools' main dialog. At this stage you have three tone mapping options available—Simplex, Receptor, and Compressor—which we shall look at in turn.

Simplex

As its name implies, the Simplex method is the simplest way of tone mapping an image using FDRTools. It works by averaging out the data in the original sequence of shots, combining the dynamic range of the original sequence into a single image.

However, the process doesn't add any local contrast adjustments, and while it does include a Postprocessing curve, this will only change the global contrast of the image. Beyond that, it offers no further way of altering your final image.

As you can see from this example, it doesn't improve on the single shot—at least not in any significant way.

Receptor

The Receptor method of tone mapping is very similar to the Simplex method, but it adds two additional controls as shown: a Compression slider and a Brightness slider.

The Compression slider allows you to vary the extent to which the shadows are compressed (a lower setting tends to result in darker shadows), while the Brightness slider allows you to change the brightness of the final image.

I haven't included an example here as the results are often very similar to those that can be produced using the Simplex method, and in this instance the best result achieved was almost a perfect match to the previous example. So, again, this is a method that doesn't offer any improvement over working with our metered exposure.

Compressor

Unlike the previous two methods we have discussed, Compressor works by increasing local contrast within an image, so it attempts to bring out detail within specific areas of an image and—more importantly—allows you to control its effect more comprehensively.

Clicking the Compressor tab at the top of FDRTools' main window opens the Compressor dialog. This provides four adjustment sliders, in addition to a Postprocessing Curve.

1

Compression The Compression slider is one of the most useful tools as it controls the local contrast in the image. This is discussed in more detail on the next page.

2

Contrast A rather self-explanatory slider, Contrast controls the overall, or "global" contrast of the image.

3

Smoothing The FDRTools help file states that the Smoothing slider "strengthens or weakens the effect of the Contrast slider." In practice, this means it can be used to fine-tune the effect of the Contrast slider.

4

Postprocessing The Postprocessing curve operates in much the same way as the Curves tool in Photoshop. It can be used to remap the white and black points within an image and change the global contrast and brightness within an image.

5

Saturation The final slider is the easiest to use, as it simply increases or decreases the amount of saturation in the final image. The default value for this slider is 1—drag it to the left to decrease the saturation, or drag right to increase it.

Compression

The Compression slider controls the amount of local contrast that is added to an image, and its default value is 5. Dragging the slider to the right will increase the amount of local contrast, while dragging it to the left decreases it. If you take a look at the two example images you can see the difference between low and high settings.

With a setting of 0, very little (if any) local contrast is introduced into the image, so it looks very similar to the images produced using the other methods.

However, when we increase the value of this slider to 10, things get a lot more interesting. This has a variety of effects on the image, the most noticeable being the foreground brightness and detail. This is because the Compressor method attempts to maximize detail in every area. As the original foreground was quite flat in comparison to the rest of the image, the changes in this area are the most pronounced.

You will also notice that the highlight detail is now more compressed, and this is especially obvious in the rocks along the edge of the lake. The rocks are not as bright compared to those in the version we produced using a low Compression setting, again because the contrast range in this small area has been brought into line with the contrast variations elsewhere in the image.

Contrast

While the Compression slider affects local contrast, the contrast slider controls the global contrast in an image. A lower setting decreases the contrast across the whole image (the dark areas become a bit brighter while the light areas become less bright), while dragging it to the right increases the global contrast.

Here, a Contrast setting of 0 produces a much flatter image, and seems to introduce highlight clipping, while using a setting of 10 produces a much more striking image, and accentuates the effects introduced using the Compression slider.

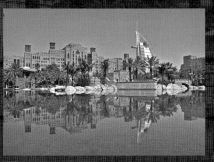

Compression: 0

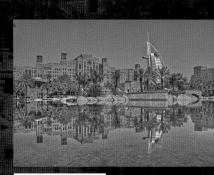

Contrast: 10

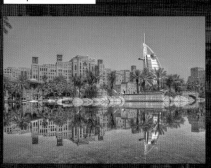

Compression: 10

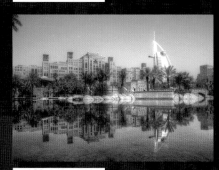

Contrast: 0

The final image made using FDRTools' Compressor tone mapping is a considerable improvement on the photograph produced from the metered exposure. There is more detail in the foreground and it now has a tonal range that balances the rest of the image. In addition, there is good detail in both the shadow and highlight areas, and the sky is also better. At this point I should add that this version is not entirely photo-realistic—it's possibly a little too vibrant, and a bit too detailed—but these effects can be moderated to produce a more subtle result.

By way of comparison, I've included two other versions of the image—one produced using Photoshop's Local Adaptation method, and a second using Photomatix Pro's Tone Compressor. In both cases, the problems we encountered with the single exposure—the dull foreground, the absence of details in the shadows, and the washed out colors—are all still evident. While Photomatix Pro has done slightly better than Photoshop in this instance, neither is as effective as the version produced

from a single exposure, and neither one comes close to matching the result from FDRTools.

However, this is not to suggest that FDRTools is the "best" HDR program. One of the key things here is not which program is best, but which sequences of images lend themselves best to the various methods available. While FDR Tools has done a better job in this instance, it will not always be the case. Sometimes, Photomatix Pro will deliver a superior result, or Photoshop—it all depends on the image and the effect you are trying to achieve.

Indeed, with some scenes it can be incredibly difficult to produce a photorealistic final image, perhaps even impossible. This is not because the techniques don't work, but because the scene doesn't lend itself to a photo-realistic treatment. For scenes of this nature I would suggest aiming for a hyper-real interpretation, rather than a photorealistic one, a topic we will be covering in detail in the next chapter.

Compressor settings

Compression: 8.2

Contrast: 6.5

Smoothing: 6.2

Saturation: 1.42

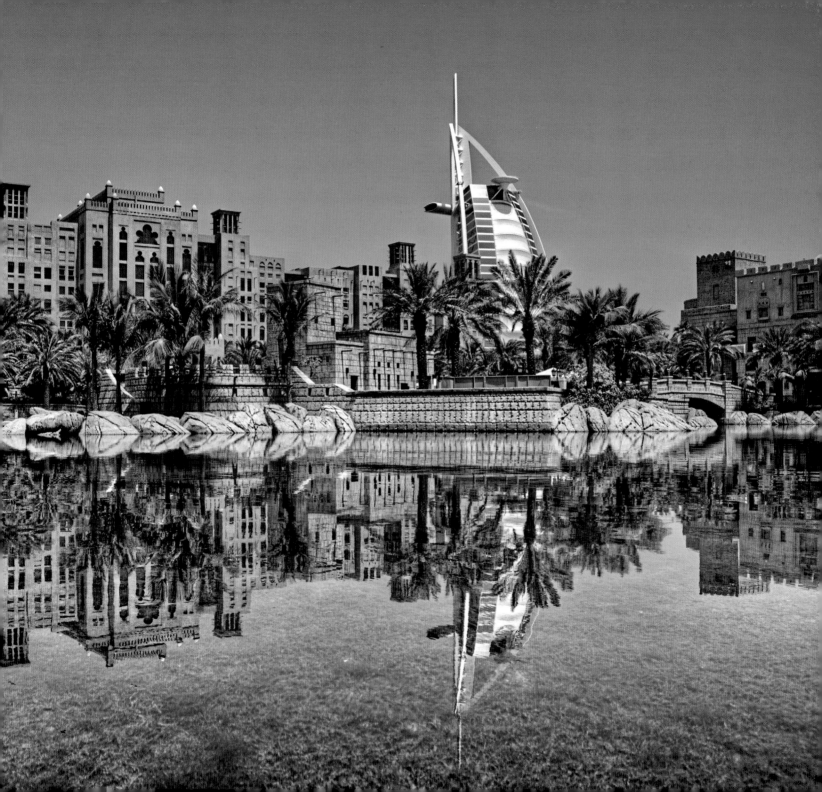

◄

*End of another
great day*
Michael Steighner

►

Untitled
**Ricardo Aguilar
Herrera**

▼◄

*Heading across
the Everglades*
Michael Steighner

▲
Heswall Beach
Pete Carr

▶▲
Storeton sunset
Pete Carr

▶▶▲
*An evening to
reflect on*
Pete Carr

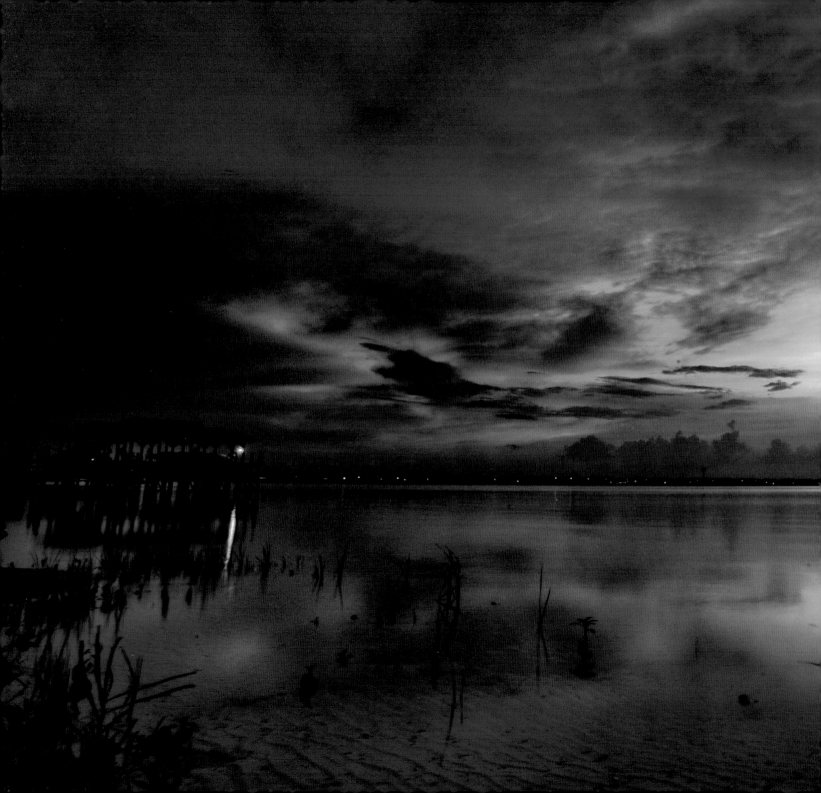

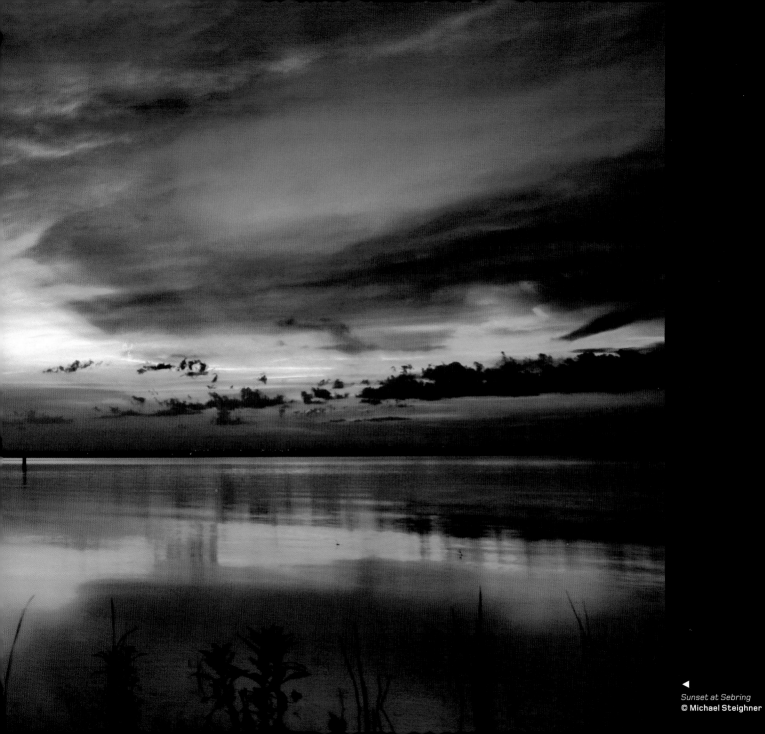

Sunset at Sebring
© Michael Steighner

Petrol paradise
Ben Willmore

▶
Plant in operation
David Nightingale

▼
Barcelona #4
David Nightingale

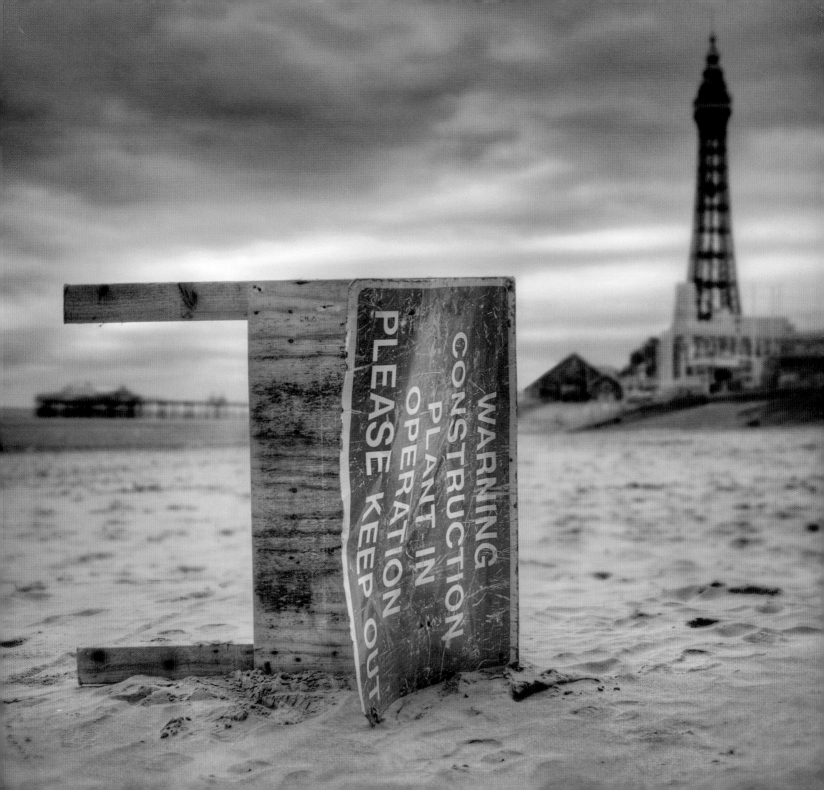

Chapter 5:
Creating Hyper-Real HDR Images

Photomatix Pro:
The Details Enhancer

In this section, before moving on to a more detailed look at two finished examples, I am going to work through the steps you need to take to tone map an image using Photomatix Pro's Details Enhancer. The Details Enhancer works by maximizing the tonal range within specific areas of an image, so there will be a lot of contrast in the sky, there will be a wide distribution of tones in foreground detail, and so on, based on the data available from your original sequence. This is one reason why it is crucial that your original exposure sequence captures both the shadow and highlight detail within in an image, because if none of the shots in the sequence contains detail in the darkest areas of a scene there will be no detail in these areas in the final tone mapped image. Likewise, if all the shots

in your sequence contain clipped highlights, this will also be incorporated into the final image. For this introduction we will use a seven shot sequence of images (with a 1EV spacing), that clearly cover the entire dynamic range of the original scene.

Having generated our 32-bit HDR file as discussed in chapter three, we are ready to begin tone mapping the image, a process that we can initiate via Photomatix Pro's Process menu (Process>Tone Mapping). This brings up the tone mapping dialog (with the Details Enhancer open by default), which can initially seem quite confusing. Over the following pages we will make sense of all the options.

–3EV

–2EV

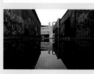

–1EV

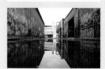

Metered exposure

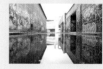

+1EV

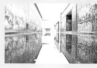

+2EV

+3EV

The Details Enhancer controls

The histogram for the –3EV exposure

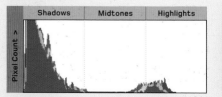

The histogram for the +3EV exposure

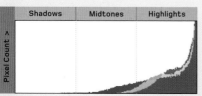

Strength

The Strength slider operates as a "master control" for the rest of the Details Enhancer adjustments. This means that when it is set to zero it almost cancels out any change you might make elsewhere, so to get the full benefit of the Details Enhancer you need to set a value larger than zero. As you go through the various changes—not just Strength—it's worth keeping an eye on the histogram as it provides useful feedback about the relative distribution of tones within the image and how these are affected by the changes you make to the settings.

The default value for the Strength slider is 70%, but I generally find that a value of 80-100% produces much more interesting results. In this example, when the Strength is increased to 100% the contrast is intensified throughout the image, but the really interesting effect is the increase in local contrast—there's a lot more detail in the brickwork, graffiti, and sky.

Color Saturation

This slider is self-explanatory, and operates in much the same way as the Saturation slider in Photoshop's Hue/Saturation tool (a value of zero produces a black and white image, while increasing the value increases the saturation).

Luminosity

The Luminosity slider controls the extent to which the tones in your image are bunched together, or compressed. Adjusting the luminosity slider also affects the overall brightness of the image, so in the example images I have also adjusted the Gamma slider (which is like the gamma slider in Photoshop's Levels tool), so that each example has roughly the same brightness level. This confuses things slightly (I'm making two changes at the same time), but it does a better job of illustrating the changes that the luminosity slider can make.

With the Luminosity set to -10 (and the Gamma at 0.48) you can see this has the apparent effect of lessening the local contrast and tonal compression within the image.

If the Luminosity slider is set to +10 (and the gamma slider to 0.96), a much more striking image is produced, with considerably more local contrast and tonal compression.

Because changes to the Luminosity nearly always require a related change to the Gamma, this setting can take some time to get right, but it can make major changes to the final appearance of your image.

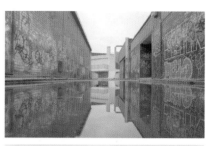

Strength: 0

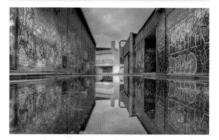

Strength: 100

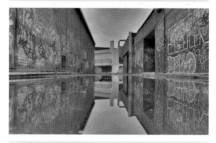

Luminosity: –1 0

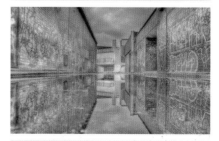

Luminosity: +1 0

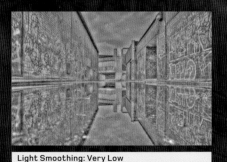

Light Smoothing: Very Low

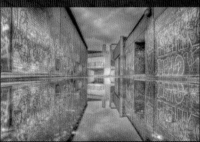

Light Smoothing: Medium

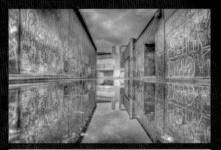

Microcontrast: –10

Light Smoothing: Very High

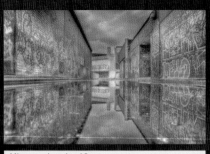

Microcontrast: +10

Light Smoothing

There are five radio buttons for setting the Light Smoothing, ranging from Very Low to Very High. When you set the Light Smoothing setting to Very Low, there will be halos around objects, particularly those that have edges against the sky or a smooth background, and the image will lack contrast.

If you increase the Light Smoothing to Very High, you will have something that looks much more realistic, with no obvious haloing and a more even tonal distribution. However, you also lose the slightly surreal quality that typifies many HDR images.

Between these two extremes, a Medium setting produces an image that looks much more interesting. Although there is some minor haloing along the tops of the walls (that could be fixed in Photoshop), the foreground and walls seem better lit, the tones are more evenly distributed throughout the image, and the HDR "look" has been retained.

As a general rule (and this is an aesthetic, rather than technical recommendation), I would suggest that you increase the Light Smoothing to the point at which any obvious haloing is removed. If you would prefer a more photo-realistic result, turn it up a bit further, while for a more surreal result you can turn it down.

Microcontrast

The Microcontrast slider controls the "level of accentuation of local details." In other words, it affects the local contrast in different parts of the image. As with the Luminosity slider, alterations to the Microcontrast slider can also affect the overall brightness of the image, so in the two examples I have included here I have also altered the Gamma to keep the overall brightness consistent. The difference is subtle, but you can see that when the Microcontrast is increased, the contrast within specific sections of the image also increases.

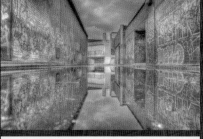

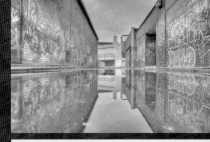

Temperature: -5

Micro-smoothing: 30

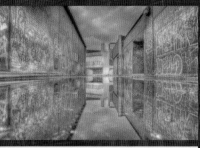

Temperature: +4

Tone Settings

The controls within the Tone Settings section of the dialog might be more familiar than some of the other tools. We have already mentioned the Gamma slider, which can be used to adjust the overall brightness (or "exposure") of the image. The other two sliders—White Point and Black Point—operate in the same way as the white and black point sliders in most editing-programs' Levels or Curves tools, allowing you to manipulate the white and black points of your image. Unless you have a very compressed histogram, I would suggest that you leave both of these set to zero and adjust the white and black points during post-production, rather than risk clipping either the shadows or highlights at this stage of the process.

Color Settings

The controls in the Color settings section are reasonably self-explanatory, especially the Temperature slider that allows you to shift the white balance of the tone mapped image. Dragging the slider to the left will produce a cooler, bluer image, while dragging it to the right adds a warmer cast to the image. The Saturation Highlights and Saturation Shadows sliders simply control the saturation of the highlight and shadow areas respectively. These are often quite useful, as tone mapping an image using the Details Enhancer can often add a disproportionate amount of saturation to the shadow areas of an image.

Smoothing Settings

There are four smoothing controls, the most significant of which is the Micro-smoothing slider. This can be used to smooth out the local detail enhancement added by the Microcontrast slider which, when used at higher settings, can introduce noise into the final image, especially in the sky or other areas of the image containing reasonably smooth tones. The default setting for this slider is 2, but it can be set anywhere between 0 and 30. Using the maximum setting of 30 produces a similar result to setting the Microcontrast to -10, so it's clear that very high Micro-smoothing cancels out the effect of a Microcontrast adjustment, producing an image that more closely resembles a "normal" photograph.

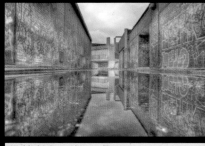

Highlight Smoothing: +45

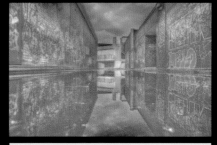

Highlight Smoothing: +100

Shadows Smoothing: +100

Highlights Smoothing and Shadows Smoothing

Both the Highlights Smoothing and Shadows Smoothing sliders allow you to moderate the global adjustments that you have made to your image at either end of the tonal range, but not the midtones, so you can turn down the tone mapping in the highlight areas and shadow areas respectively.

Of the two controls, Highlights Smoothing is probably the most useful as it allows you to control the effect of the tone mapping on the skies within your images, an area that can often look over-processed or contain high levels of noise. As with all the controls within the Details Enhancer dialog, the actual settings you need will vary from

image to image, but in this instance a Highlights Smoothing setting of 45 produces a final version where the sky looks quite natural. Increasing the value to 100, affects the brighter areas in the rest of the scene, resulting in a flat, dull image, with very little highlight detail.

For the majority of images, the Shadows Smoothing control is less useful, as it will be rare that you need, or want, to moderate the effects of any adjustments to local contrast in the darker areas of your image. If you do use it, you need to be careful not to set too high a value as, like the Highlights Smoothing option, this can produce a dull-looking image.

Shadows Clipping

The final tool in the Details Enhancer dialog is Shadows Clipping, which allows you to intentionally clip the shadows in your tone mapped image. This can be useful if you want to reduce the amount of noise in the darkest areas. However, clipping the shadow detail at this stage isn't a good idea, because the preview window isn't entirely accurate (so it can be difficult to judge exactly how much clipping will occur), and this is a task that can be performed much more accurately in your image-editing program.

That finishes off the tools in the Details Enhancer and what they do, so now it's time to put it into practice. Over the following pages we will explore these controls in a bit more detail, and work through two examples that will show you how to optimize the settings to produce images that meet your creative expectations.

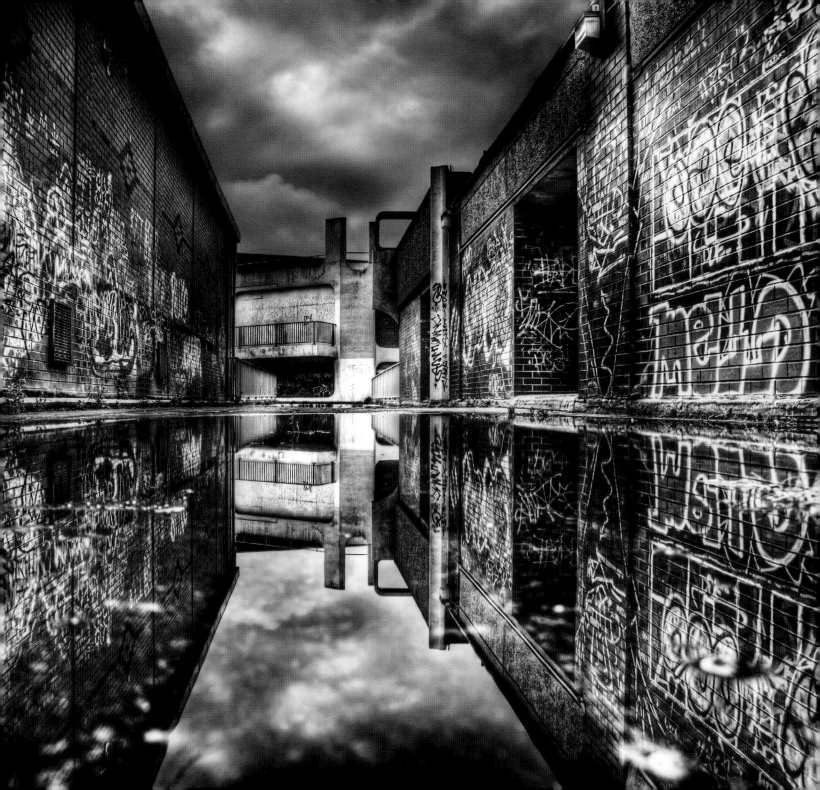

The Details Enhancer: Example #1

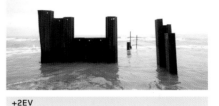

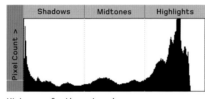

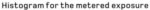

−2EV

Shadows	Midtones	Highlights

Pixel Count >

Histogram for the −2EV exposure

Metered exposure

Shadows	Midtones	Highlights

Pixel Count >

Histogram for the metered exposure

+2EV

Shadows	Midtones	Highlights

Pixel Count >

Histogram for the +2EV exposure

As you can see from the images and histograms of this three-shot sequence, this scene is a good candidate for HDR. The EV range is higher than the dynamic range of the camera's sensor, and the interesting detail in the metal structure has been all but lost in the metered exposure. A single shot of this scene— even if it could have captured the entire dynamic range of the original scene— wouldn't have been especially interesting.

Before we go through the various stages of processing this sequence, it's worth taking a look at the histograms for each of the images to see what I did wrong or, rather, how this sequence could have been done better.

If you look at the darkest exposure, you will see that there is quite a lot of room at the rightmost edge of the histogram, so while it captures all of the highlight detail in the original scene, it's quite a bit darker than is necessary.

By the same token, while the lightest exposure has recorded all the detail in the darkest areas of the image, the gap at the leftmost edge of the histogram is very small. What this indicates is that the metered exposure isn't ideal—the entire sequence of images should have been overexposed by around two-thirds of a stop. This would have lightened the darkest exposure (which would still have captured all the highlight detail), but more importantly, it would have lightened the lightest image, so the detail in the darkest shadows would have been recorded using more data.

However, despite this, creating the HDR image from the three initial exposures was a straightforward process—the only choice I made that was especially significant was to select the option to attempt to remove the background movement, in this case caused by the small waves moving between the three exposures.

While I tend to prefer more extreme HDR images, I always take a quick look at how the default settings within Photomatix Pro will tone map the image, not least because this provides a uniform starting point with which to evaluate the various sequences I process. In this instance (*pic A*), the default settings provide a good starting point; there's a nice tonal balance between the metal structures and the rest of the image, and a reasonable amount of detail in both the metal and the waves. There is still room for improvement though.

The first step is to increase the Strength, in this instance taking it all the way up to 100 (*pic B*). The image immediately looks better as the sky is a bit darker, the structure and foreground a little lighter, and the detail in the metalwork has been accentuated.

A

Tone mapped using the default settings

B

Strength: +100

C

Histogram with Strength set to +100

D

Histogram with White Point and Gamma adjusted

However, the histogram in the Details Enhancer dialog (pic C) shows that increasing the Strength has caused some minor clipping to the highlights. To correct this, I reduced the White Point to 0.015 and decreased the Gamma to 0.91 to compensate for the decrease in brightness caused by altering the white point.

This doesn't make a huge change to the appearance of the image, but it does bring back the highlights (pic D), so that the very brightest highlight detail will be retained in the final image.

The next three changes I made were to increase the Microcontrast to +5, the Luminosity to +3, and the Gamma back to its default value of 1 (pic E). The first of these changes increases the fine scale detail in the tone mapped image, and with this image the effect is most noticeable in the metal structure, with the rust,

scratches, and marks left by the waves all becoming more pronounced.

The change to the Luminosity requires a little more explanation. As explained, the Luminosity slider controls the amount of tonal compression in an image, so increasing the Luminosity means the tones within an image become more compressed. However, at the same time this gives the appearance of an increase in local contrast. In other words, this change further accentuates the fine scale detail within the image.

The third change—resetting the Gamma slider to its default value—compensates for the previous two changes, which also lightened the image. Generally speaking, you will find that you will need to adjust the Gamma slider quite frequently to compensate for changes introduced using other controls and sliders.

E

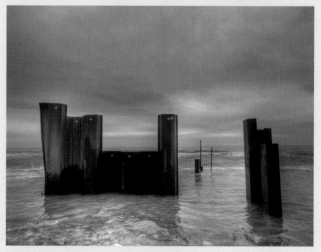

Increasing the Microcontrast and Luminosity

Microcontrast: +5

Luminosity: +3

Gamma: 1

F

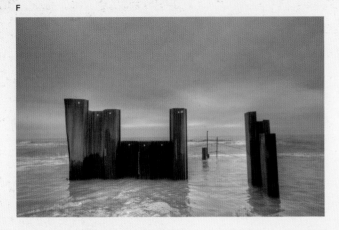

Micro-smoothing: 15

**Increasing the
Micro-smoothing**

To reduce the noise in the image,
I increased the Micro-smoothing to
15 (*pic F*), but this had two negative
consequences. First, it made a global
change to the image, reducing the local
contrast in all areas and producing an
image that was noticeably less striking.

The second consequence of this
change was that it also removed a lot of
the fine scale detail in the foreground—
detail that can't be added in any post-
processing. So in this case, resetting
the Micro-smoothing and generating
an image with an unacceptable amount
of noise preserved both the overall
appearance of the image I was aiming
for, and retained the fine scale detail
in metal structure. The noise can be
dealt with later.

In terms of the other Details Enhancer
settings, I left these all at their defaults,
choosing not to make any color changes
or alterations to the Light Smoothing
and other options. With the tone mapping
complete it was time to press Process
and wait for my image to be generated.

Post-production

After saving the tone mapped image as
a 16-bit TIFF, the file was opened up in
Photoshop for some final adjustments.
I started by increasing the global contrast
using the Curves tool (as described in the
next chapter). With most tone mapped
images, unless you adjust both the White
Point and Black Point sliders to clip the
highlights and shadows when you tone
map an image, it will be inevitable that
the final image will look a bit flat. In
these cases, the Curves tool is ideal for
reintroducing some contrast into an
image, without clipping the shadow or
highlight detail.

I then fixed the haloing above the top of
the metal pillar on the left of the image.
This isn't the only visible haloing—it's
evident right along the top of the
structure—but it was only this section
of the image where it seemed especially
distracting. Again, this technique is
covered in the next chapter.

Finally, I used Noiseware Professional
to remove the noise in. It's now a big
improvement on any of the original shots
in the exposure sequence, and a far more
striking photograph.

**Photomatix Pro Details
Enhancer settings**

Strength: 100	
Color Saturation: 60	
Luminosity: 3	
Light Smoothing: Medium	
Microcontrast: 5	
Micro-smoothing: 2	
Highlights Smoothing: 0	
Shadows Smoothing: 0	
Shadows Clipping: 0	
Gamma: 1	

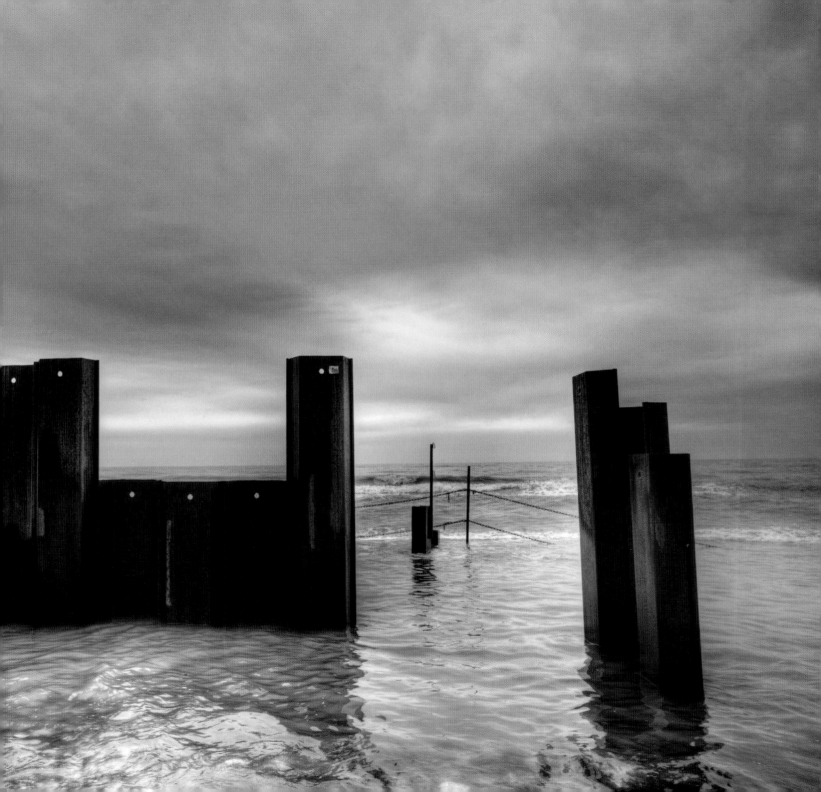

The Details Enhancer: Example #2

In the previous example, the initial tone mapped pciture was broadly similar to the final image, with just a moderate amount of contrast added in Photoshop after the tone mapping to complete the image. With this image, however, there is a much greater disparity between the tone mapped image and the final version. Although the tone mapped image was adjusted in exactly the same way as the previous one—with the addition of a Curves adjustment layer in Photoshop—this time the increase in contrast was much greater.

My reason for including this example is because it neatly demonstrates one of the more counter-intuitive aspects of creating hyper-real HDR images; you often need to produce a tone

mapped image that seems to take you in the opposite direction to the result you're aiming for. In this particular case, the initial tone mapped image is especially dull and flat, yet with the addition of a single adjustment in Photoshop it can be transformed into a much more compelling image. Before we discuss the reasons for this though, let's take a look at the original 5-shot sequence (taken at 1¹/₃EV intervals).

While a lot of the exposure sequences you will shoot will be based around the metered exposure, I needed to bias the exposures in this sequence quite heavily toward underexposure. The reason for this is because the sun was in the shot, and while it was partially obscured by cloud (and shot fairly early in the

morning), it was still very bright in comparison to the rest of the scene. In this instance, an exposure of -4EV was needed to capture a full range of tones in the highlight areas, while overexposing by only 1¹/₃EV from the metered exposure recorded the shadow detail.

Having created the HDR image using Photomatix Pro, the next stage was to check how the default settings would tone map this image. In this instance, the default settings look good (below left), and if the default image is taken into Photoshop and a Curve added to increase the contrast, it could easily be considered "finished" without even adjusting any of the tone mapping parameters (below right).

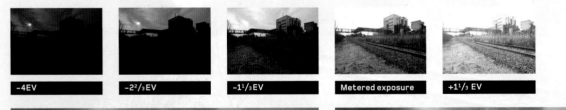

-4EV -2²/₃EV -1¹/₃EV Metered exposure +1¹/₃ EV

Produced using the default settings in Photomatix Pro

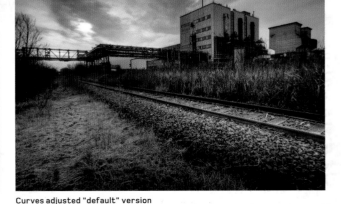

Curves adjusted "default" version

Histogram for the "default" tone mapped version

Histogram for the final tone mapped version

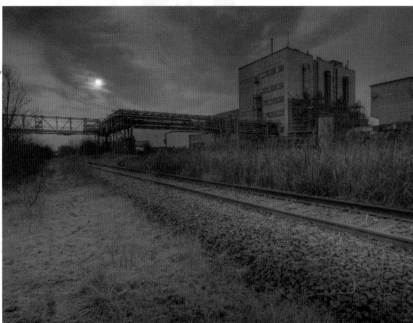

Initial tone
mapping changes

White Point: 0
Strength: 100
Gamma: 0.50

So, if the default tone mapping settings can produce a great end result, why did I go to all the trouble of creating a much flatter version that required a greater increase in contrast?

There were two main reasons. First, the default settings introduced some highlight clipping—most noticeable around the sun. This could have been fixed easily by a White Point adjustment, and is hardly significant, but the second reason is more complex; I wanted to produce an image with a more unified tonal range.

For example, if you take a look at the line of bushes down the left side of the image you will see that these are much darker in the version that was tone mapped using the default settings. Likewise, the sky

is quite a bit brighter compared to my final version overleaf, and there are also dark and light patches in the foreground grass. The flatter version— once I increased the contrast using the Curves tool—has a much more unified tonal range, so the line of bushes is lighter, the sky darker, and the grass in the foreground appears uniformly lit.

If you compare the histograms of the default version and the flatter image, you will see that the tones are bunched toward the center of the histogram in the adjusted version, so the majority of the tones within the image fall into the midtone area. This means that when the contrast is increased, it will be increased uniformly across the different areas of the picture.

If the technical aspects of this don't make a great deal of sense, don't worry—the key point here is that if you want your final image to have a balanced tonal range. The easiest way to achieve this is to tone map the image to produce a version with a narrow histogram, so you get a flat image with the majority of tones bunched into the midtone values.

The first set of changes I made involved lowering the White Point to 0 and increasing the Gamma to 0.5 to compensate. I then increased the Strength slider to 100. As you can see, the tonal range of the image is more compressed (above).

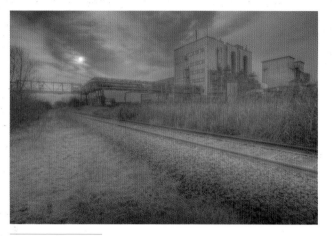

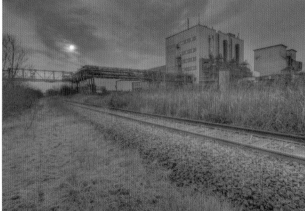

**Secondary tone
mapping changes**

Luminosity: 10

Color Saturation: 28

Gamma: 0.70

**Final tone
mapping changes**

Light Smoothing:
Medium

Microcontrast: 6

Micro-smoothing: 15

To make sure that the tonal range was as compressed as possible, I increased the Luminosity to +10. In addition to increasing the tonal compression, this also lightened the image overall, and increased saturation. To compensate, I adjusted the Gamma to 0.70, and lowered the Color Saturation to 28. The tone mapped image is now looking really flat, and not at all attractive.

The next stage involved lowering the Light Smoothing value to Medium (down one notch from the default value), after which I increased the Microcontrast to +10. This adds a lot of fine scale detail, but also introduces a variety of anomalies around the pipes leading from the factory. In this instance, rather than commit myself to spending a lot of time repairing these in Photoshop, I reduced the Microcontrast to +6 and increased the Micro-smoothing to 15, sacrificing

some of the detail I could have brought out in this image in favor of producing an image that would be much easier to edit once it was tone mapped.

Post-production

While the tone mapping stage was more complex in this example—simply because it was counter-intuitive—the post-production was quite a bit easier. In Photoshop, I started by darkening the sky immediately above the pipework leading from the factory to get rid of the slight haloing, then performed the most significant change—adding a strong "S" Curve to expand the tonal range. The picture immediately comes to life as the contrast is lifted across the frame, and the "default" tone mapped and edited version pales in comparison.

**Photomatix Pro Details
Enhancer settings**

Strength: 100

Color Saturation: 28

Luminosity: 10

Light Smoothing:
Medium

Microcontrast: 10

Micro-smoothing: 15

Highlights Smoothing: 0

Shadows Smoothing: 0

Shadows Clipping: 0

Gamma: 0.70

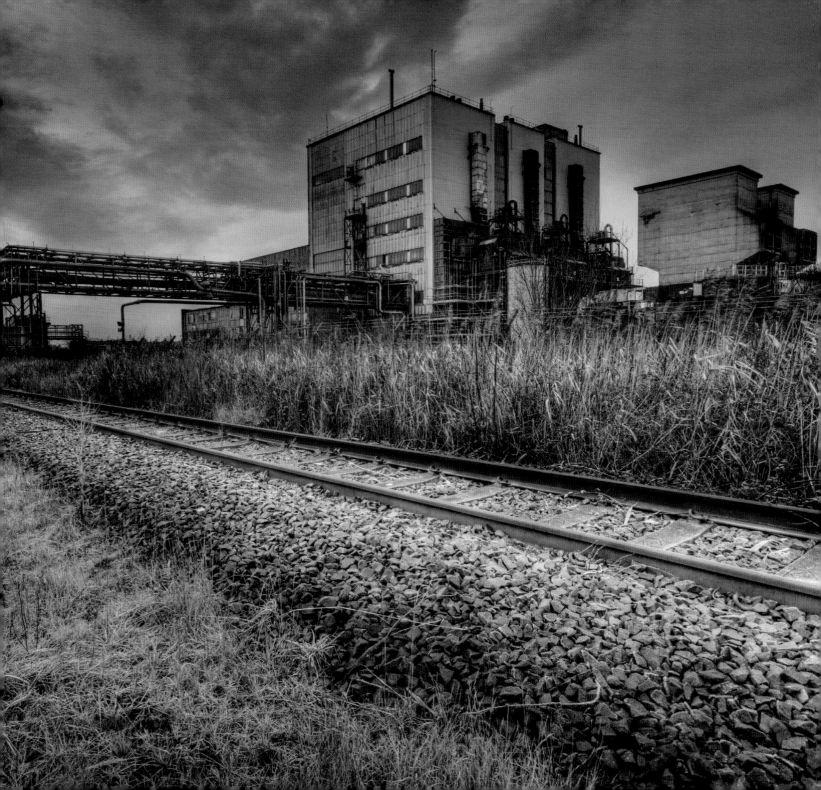

FDRTools

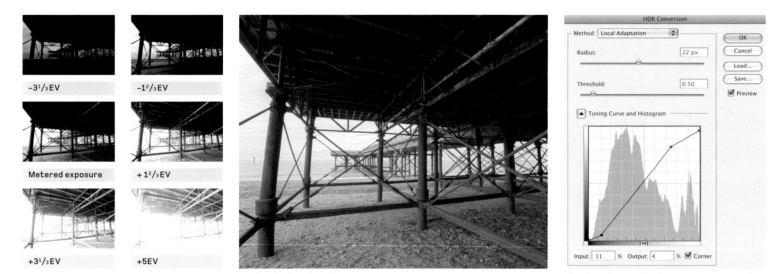

−3¹/₃ EV −1²/₃ EV

Metered exposure +1²/₃ EV

+3¹/₃ EV +5 EV

Produced using Photoshop

The Photoshop Local Adaptation settings used

Toward the end of the previous chapter I indicated that FDRTools is one of the better programs to use if you are aiming to produce a photo-realistic result. While the final appearance of an image is largely determined by the program you use to tone map the HDR image (and the strength and type of the settings you apply), the original scene also contributes strongly to how real or unreal the final image will appear. Specifically, when you photograph a scene that covers a very large EV range, or when areas of the original scene would naturally be either very bright or very dark, an HDR image can look unreal, or hyper-real, despite your intentions to the contrary. The reason for this is that the final picture will look radically different to our expectations of how that scene *should* appear. In other words there is such a striking mismatch between our perceptual expectations and the final

image, that the picture inevitably looks unreal.

My reason for reiterating this are twofold. If you can develop a better understanding of the various processes that go into constructing an HDR image, and the relationship between the EV range of the original scene and how this can be translated into a tone mapped image, you will have a much better chance of producing good results. Second, while FDRTools is better suited in most instances to producing photo-realistic images, it can also be used to produce hyper-real or surreal results when given the right set of original exposures. In some cases it can also do a much better job of doing this than either Photomatix Pro or Photoshop.

To demonstrate this, let's take a look at a sequence of images shot from beneath

a pier. As you can see from both the images and the histograms, the EV range was so high that it required a sequence of six images covering a range from −3¹/₃ EV to +5 EV to capture the full dynamic range. Before we take a look at how to use FDRTools to process these images, let's take a look at how Photoshop and Photomatix Pro handle this sequence.

Photoshop

As you can see above, the version produced using Photoshop's Local Adaptation method isn't especially impressive. Overall, it is very dull and, despite the initial exposure sequence capturing a full range of tones in the darkest areas of the original scene, the underside of the pier has still ended up very dark.

Photomatix Pro

As you can see below, using Photomatix Pro's Details Enhancer method to tone map the HDR image produces a very different result to Photoshop. The underside of the pier looks a lot more interesting—it's brighter and there's more detail—but the image as a whole has a very strange appearance that makes it look as though it is embossed, or printed on an uneven surface.

The reason for this is because the Details Enhancer uses data from several of the images in the sequence to maximize the local contrast within different areas of the image. As such, it has struggled to delineate between the foreground and

background details; the haloing around the legs of the pier is quite pronounced and the light smoothing is uneven.

However, the settings for the first image (below left) include a high Luminosity setting and medium Light Smoothing; settings that tend to maximize the tone mapping effect, and accentuate the problems we have just identified.

Unfortunately, is not simply a case of reducing the Luminosity and increasing the Light Smoothing. Adjusting the settings in this way (below right) produces an image that still has some unevenness—most noticeable around the fine scale structure of the pier in the centre of the image—and it doesn't look much better

than the version we produced using Photoshop. So, the only way to reduce the processing artifacts introduced at the stronger settings is to reduce them to a point where the final image lacks any real merit or impact.

It would appear that neither Photoshop nor Photomatix Pro are capable of producing an especially good result with this sequence—at least not one that doesn't require an extensive amount of retouching during post-production, or a radical rethink regarding how we want the final image to appear.

So can FDRTools do any better?

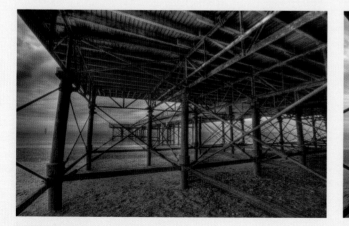

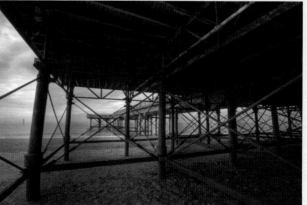

Full tone mapping changes

Strength: 90	White Point: 0.002
Color Saturation: 33	Black Point: 1.692
Luminosity: 10	Gamma: 0.67
Light Smoothing: Medium	Micro-smoothing: 1
	Highlights Smoothing: 0
Microcontrast: 10	Shadows Smoothing: 0
	Shadows Clipping: 0

Full tone mapping changes

Strength: 90
Color Saturation: 33
Luminosity: 0
Light Smoothing: Very High
Microcontrast: 9
White Point: 0.002
Black Point: 1.692
Gamma: 0.58
Micro-smoothing: 1
Highlights Smoothing: 0
Shadows Smoothing: 0
Shadows Clipping: 0

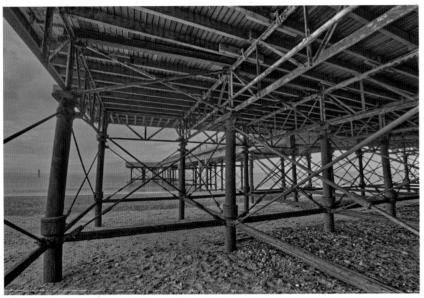

HDR sequence generated using FDRTools Separation method

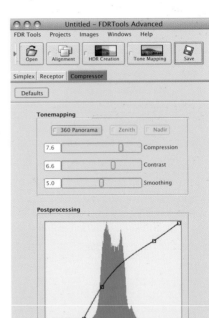

The final Compressor tone mapping settings

FDRTools

Fortunately, FDRTools does produce a much better initial image. While it's not as surreal (or dramatic) as some of the images we created earlier in this chapter, it is a considerable improvement on anything we could produce using Photoshop and Photomatix Pro. True, there is some minor unevenness in the lighting around the fine scale structure of the pier, but the image as a whole is a lot more striking—especially in terms of the detail and brightness of the underside of the pier.

The tone mapping settings used for this image were relatively moderate (Compression 7.6 and Contrast 6.6),

so the main reason this version is an improvement over Photoshop and Photomatix lies in the way FDRTools combines the original image sequence. Unlike the other programs, FDRTools offers a variety of methods for combining your images, and one of these—the Separation method we explored earlier—determines each pixel in the final pictures from a single source image, rather than averaging out the values across a range of images.

In other words, the areas of sky in the background are likely to be sourced from a single image, while the legs of the pier will be sourced from another, and so on. By combining the images in this way, the processing artifacts we encountered

with Photomatix Pro are almost entirely eliminated. The net result is that the initial tone mapped image lets us produce a final tone image that looks considerably better, and requires much less post-production to get absolutely right.

Ultimately, though, if your primary interest in HDR imagery centers around producing surreal or hyper-real images, then it's likely that Photomatix Pro will produce the best result for the majority of the sequences you shoot. However, for some sequences, it is simply incapable of producing a good result, in which case FDRTools may provide a better solution.

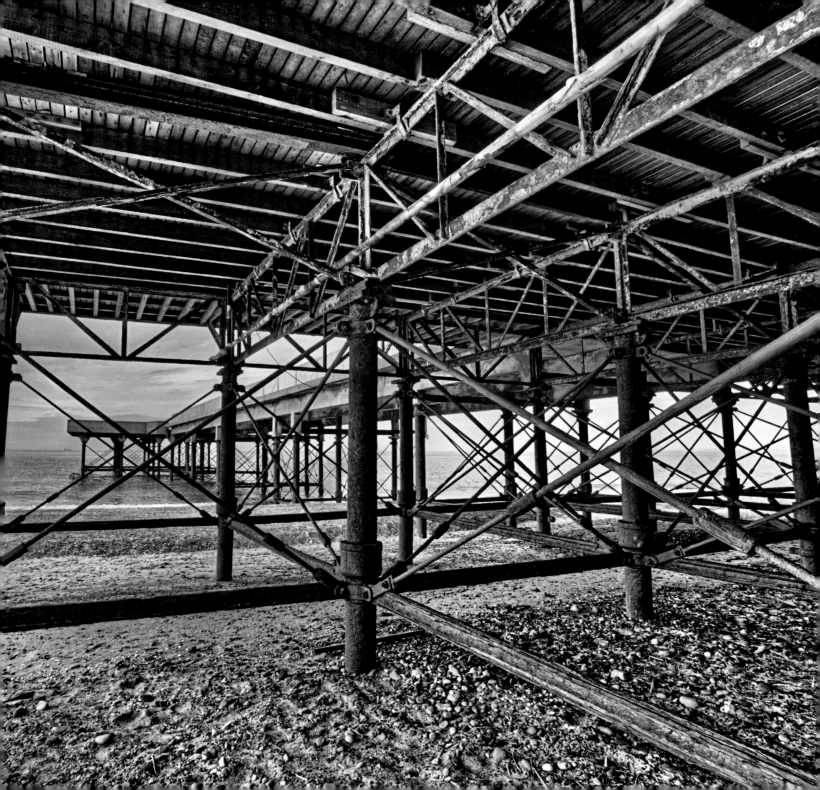

◄

Grease monkey's habitat
Ben Willmore

►

Heavenly Reflections
John Maslowski

◄

Hong Kong from the Peak on a Summer's Night
Trey Ratcliff

►

Bumby Arcade
Brooks Potteiger

▼◄

The Minton floor inside St Georges Hall
Pete Carr

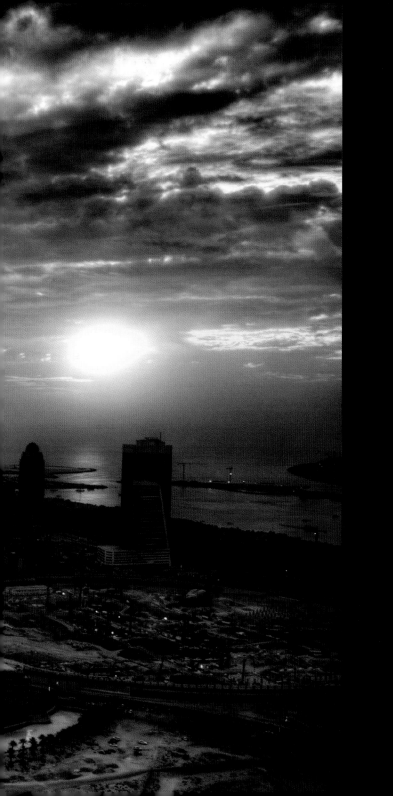

▲

Stairs at Fisher Island
Michael Steighner

◄

Dubai from the roof
Catalin Marin

◀

Boardwalk Night
John Maslowski

▶

*A private
Inaugural Party -
South Florida style*
Michael Steighner

▼◀

The city windy
Brooks Potteiger

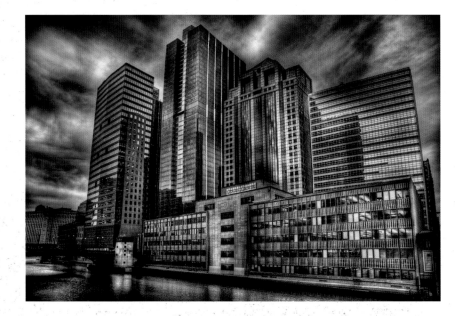

◄

At the end
David Nightingale

►

Shanghai up close
Michael Steighner

It's Shou... in

Fleetwood Pier's ...

...ERY FRIDAY & ...

... 01253 8 8685 f...

... 1 til 2 ...

Hosted by JP ...

Dine - 'Eat as Much as You...

Dance - with 'The Magic Sh...

Cabaret - Guest Cabar...

ONLY £10 per ...

(booked & paid in ...

It's the perfect fun...

It's showtime!
David Nightingale

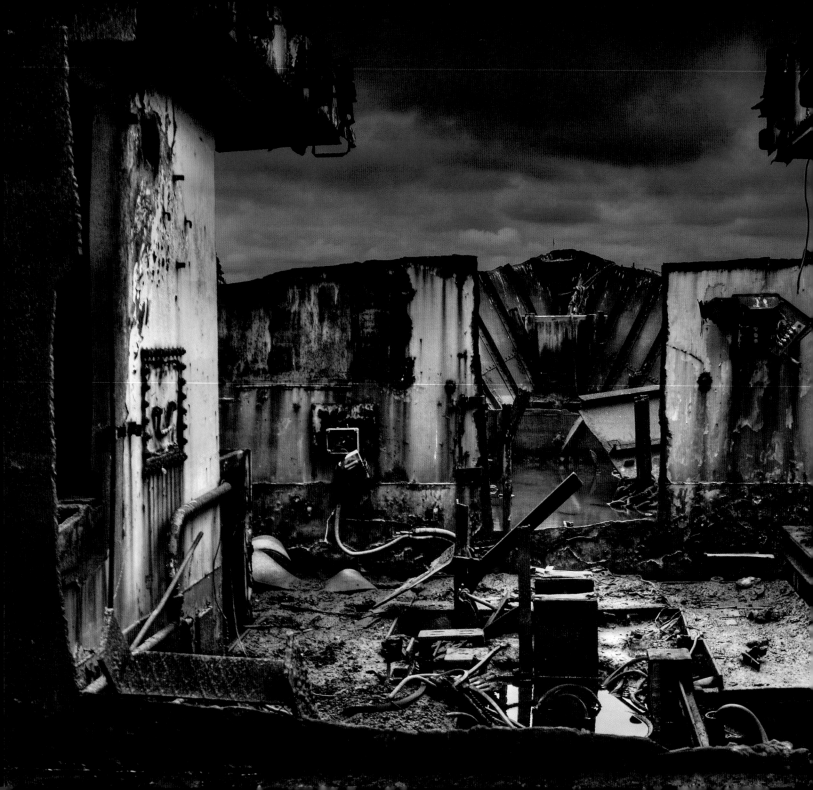

Chapter 6:
HDR Post-production

Removing Noise

-3EV

-2EV

-1EV

Metered exposure

+1EV

+2EV

+3EV

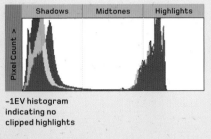

-1EV histogram
indicating no
clipped highlights

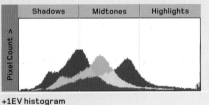

+1EV histogram
indicating no
clipped shadows

When HDR images first started appearing on the web, one of the things that was most often commented on was the amount of noise, especially in the darker areas of the final images. At the time, the novelty value of HDR was sufficiently high that this was often forgiven, but as the technique has matured, the audience has become less forgiving. In the case of an HDR image constructed from a bracketed sequence, much of the noise can be avoided if you make sure you provide adequate coverage of the tonal range from the outset.

This sequence was shot on an overcast day, using a 1EV spacing, and as you can see from the histograms for the -1EV shot and the +1EV shot, a three shot sequence would have been sufficient to capture the entire dynamic range, with no clipping of either the highlights or shadows, so it looks like using these

three shots to construct the HDR image—rather than the full seven-shot sequence—would be possible.

If you take a closer look though, you can see that this would be a mistake. To illustrate this I used Photomatix Pro to produce three HDR images. The first was constructed using three shots (-1EV, the metered exposure, and +1EV), the second used five images (-2EV to +2EV) and the third used all seven exposures, from -3EV to +3EV. Each of the resultant HDR images was then tone mapped in Photomatix Pro using identical settings. When they are enlarged, the noise is considerably more pronounced in the three-shot version, a bit better in the five shot one, but best of all in the seven shot version because the lightest shot of the sequence—+3EV—recorded more data in the shadows.

Produced using 3 exposures

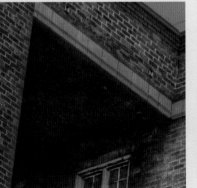

Produced using 5 exposures

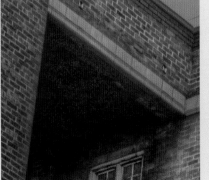

Produced using 7 exposures

Setting and previewing the blur

Unwanted blurring of other details

However, even with a seven shot sequence there is still some noise in the final image, and at this stage, you have four choices. If the noise is minimal, and confined to only a few small areas, you can probably ignore it as it won't be obvious to anyone other than the most diligent of observers. Alternatively, if the noise is only visible in the very darkest areas of the image you could use a Curve to clip the shadow detail slightly, making these areas of the image black, and obscuring the noise. A further option would be to blur the noise in Photoshop to disguise it, and the final solution is to use a noise reduction plug-in in Photoshop. It's the two last solutions that I will look at here.

Adding blur in Photoshop

Blurring noisy areas of an image is a relatively straightforward task. The first thing to do is duplicate your image layer, either by right-clicking the background layer in the layers palette (and selecting Duplicate Layer), or via the Layer menu (Layer>Duplicate Layer). Having created a duplicate layer, zoom in to a 100 percent preview (View>Actual Pixels) so you can see the noise clearly.

At this stage, you're ready to add some blur. There are a variety of blur filters available within Photoshop but the one I would recommend is Gaussian Blur (Filter>Blur>Gaussian Blur). The dialog for this filter is minimal—the only setting you can change is the radius. For most high resolution images, a setting of around 1 pixel is sufficient to remove the majority of the noise, but you might want to lower this value (in 1/10 increments) if the noise is relatively weak, or use a higher value if

it is especially pronounced. As you adjust the setting you can see the result in the small preview window within the dialog, but you can also preview the whole image if you have the Preview button checked.

Once you find a value that blurs the noise by a sufficient amount, press the OK button to apply the filter. This softens the entire image, including areas that would be better left sharp (such as the windows and brickwork in this example). This is easily remedied—either erase the bits you don't want blurred (using the Eraser tool), or add a layer mask and paint over the areas of the mask where you would like the original, unblurred layer to show through.

Using the Eraser will produce smaller files, because you are physically removing data in the blurred layer, while masking allows you to revisit the changes you make so you can more precisely edit where the blurring is applied.

Using noise removal plug-ins

As well as manually removing noise using Photoshop's blur filters, there is a variety of plug-ins available, all of which offer a range of automatic and semi-automatic ways of reducing noise. The two I use most often are Noise Ninja and Noiseware Professional. Both of these are a better alternative to the manual blurring technique because they analyze the image to identify noise, rather than applying a global alteration. This means the noise reduction is performed without compromising the fine detail in other areas of the image.

They also provide a greater range of settings that can be tweaked and adjusted to provide the best possible noise reduction for each image you are working with. In the case of Noise Ninja you can alter a wide range of settings including the Strength and Smoothness of the filter, and the Contrast and Sharpness of the final image. You can also use a "noise brush" to apply the noise control to specific sections of your picture.

Noiseware Professional, on the other hand, offers a range of presets to choose from, each of which is tailored to a particular style of photography, such as landscapes, night shots, and so on. However, you can also change the intensity of noise reduction applied to different tonal areas, allowing you to target shadow noise without affecting the midtones or highlights, for example.

Photomatix Pro Details Enhancer settings

Strength: 100

Color Saturation: 21

Luminosity: 10

Light Smoothing: Medium

Microcontrast: 10

White Point: 0.000

Black Point: 0.000

Gamma: 0.77

Temperature: 0

Saturation Highlights: −2

Saturation Shadows: 0

Micro-smoothing: 2

Highlights Smoothing: 0

Shadows Smoothing: 0

Shadows Clipping: 0

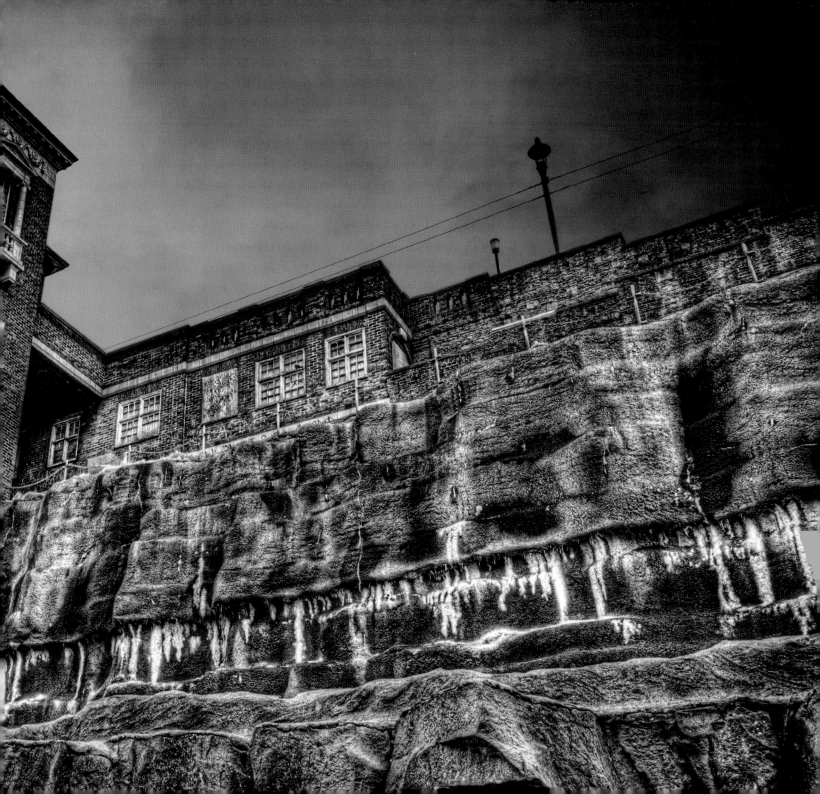

Removing Halos

One of the difficulties you will face when tone mapping your HDR images—especially when working with Photomatix Pro—is that the process will often introduce halos around objects within your pictures, most commonly when they are set against a much lighter background. Clearly, the easiest way to deal with this problem is to avoid generating them in the first place (by using a higher Light Smoothing setting), but with some images this just isn't possible, at least not without producing a much less interesting image. For these two tone mapped images of a disused railway line, one was produced using Very Low Light Smoothing (top), while the other used a High Light Smoothing setting (bottom).

The one produced with the Light Smoothing set to Very Low is clearly a better image—at least in terms of the foreground detail—and it makes the other version looks very dull and flat. What you will notice, though, is the considerable amount of haloing along the horizon and around the large tree on the right. In some cases, a minor amount of haloing isn't an issue, but in this instance the effect is far too pronounced to be acceptable. So, it's a choice of accepting a weaker, flatter image with High Light Smoothing, or correcting the haloing in an image-editing program, which is what we will do here.

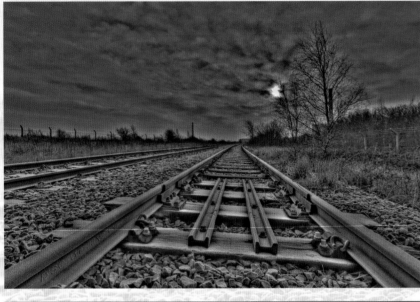

Photomatix Pro Details Enhancer settings

Strength: 100
Color Saturation: 28
Luminosity: 10
Light Smoothing: Very Low
Microcontrast: 10
White Point: 0.000
Black Point: 0.000
Gamma: 1.13
(other settings left at default levels)

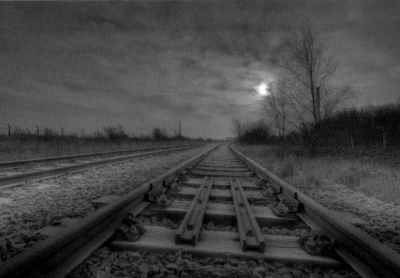

Photomatix Pro Details Enhancer settings

Strength: 100
Color Saturation: 28
Luminosity: 10
Light Smoothing: High
Microcontrast: 10
White Point: 0.000
Black Point: 0.000
Gamma: 0.65
(other settings left at default levels)

The way to do this in Photoshop (and most editing programs) is to use the Clone Stamp Tool to replace the lighter (halo) sections of sky with the darker sky above it. Once you have selected the Clone Stamp Tool you need to select an appropriate Master Diameter (size) and Hardness for the tool by right-clicking within the borders of the image to open the tool options dialog. Pick a size that's appropriate to the area you want to change, and a Hardness of 0%, as this will make sure that the alterations you make to the image are blended smoothly.

The next stage is to pick a "source" area to clone from, which is the area of the image that will be used to replace the lighter halo. Hold down the Option key (the cursor will change to a target symbol) and click the area you want to select.

Once you have selected your source area, move your cursor to the "target" area (the area containing the content you want to remove) and click. When you do, this simply paints over the area of the image you want to change with the source area.

However, to darken the halos, rather than simply replacing one area of the image with another, there is one further step you need to take.

The Clone Stamp Tool Altering the size and hardness of the Clone Stamp Tool

Picking a source point

Cloning

The key to only correcting the halos is to change the blending mode of the Clone Stamp tool from Normal to Darken, using the Effect Mode dropdown menu in the toolbar. When you change the blend mode to Darken, Photoshop evaluates the brightness of the target area in relation to the source area and only darkens areas that are lighter. Areas that are already darker, such as the foliage and fence in this example, are left at their original value.

The end result, providing you make sure that you don't inadvertently clone out any detail that should be in the image, is that the halos will be removed. The benefit of this technique is that it lets you produce a more dramatic image at the tone mapping stage, which you can subsequently fix, rather than having to accept a less impressive image from the outset.

Cloned using the Darken blending mode

Photomatix Pro Details Enhancer settings

Strength: 100

Color Saturation: 28

Luminosity: 10

Light Smoothing:
Very Low

Microcontrast: 10

White Point: 0.000

Black Point: 0.000

Gamma: 1.13

(other settings left at default levels)

Enhancing Contrast Using Curves

One of the biggest problems you will encounter with your tone mapped images—especially if you're aiming to produce a more surreal final image—is that the initial result can often appear quite flat, with "muddy" shadows and highlights that don't really sparkle. If you look at the example below you will see what I mean; the tone mapped image is dull in comparison to the final image. Yet the only difference between the two images is the application of a Curve in Photoshop—a single edit that can transform a picture.

The Curves tool lets you make simple adjustments to the tonal range of an image. It also provides an exceptionally high level of control as it lets you manipulate both the white and black points, plus 15 additional anchor points that can be positioned anywhere within the original image's tonal range.

To use the Curves tool you need to either select it from the Image menu (Image> Adjustments>Curves) or create a Curves adjustment layer (Layer>New Adjustment Layer>Curves).

The default points on the curve are at the very ends of the line—the top right and bottom left corners, which represent the white and black points in the image respectively. By shifting the anchor points from their starting positions the white and black points can be adjusted to darken shadows and brighten highlight.

Adjusting the white and black points makes the Curve (which is currently a straight line) steeper. This stretches, or expands, the tones in an image, increasing the overall contrast. Conversely, if you decrease the slope, you compress the tonal range and reduce the contrast in the image.

Original tone mapped image

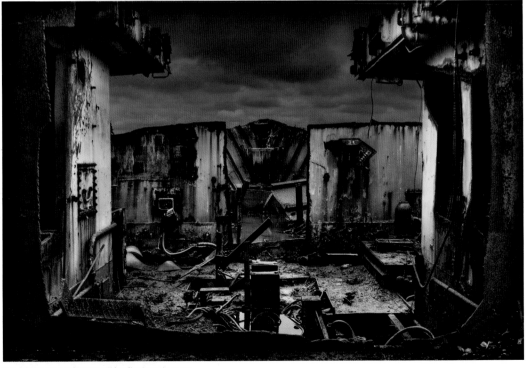

Final tone mapped image with adjustment curve

The Curves tool can also be used to adjust the midtones in an image. To do this, you need to add an anchor point to the Curve, by clicking the position on the Curve where you want to insert it. To control the midtones, this needs to be roughly half way between the black point and white point. If you drag this anchor point toward the top-left corner of the dialog it will increase the brightness of the midtones, while dragging it down toward the bottom-right corner will decrease the brightness. The further you drag the anchor point, the greater the brightening or darkening effect.

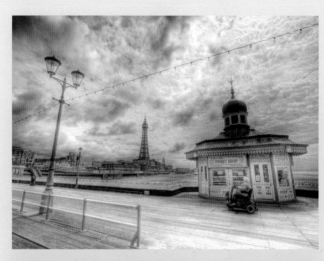

Lightening the midtones

The Curves dialog

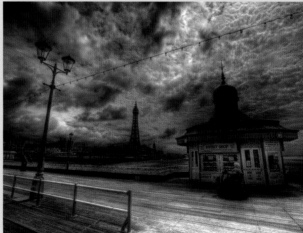

Darkening the midtones

Adjusting the black point

Adjusting the white point

A basic S-Curve

The most common Curve—the S-Curve—boosts contrast in an image without clipping. The shape of the S, and the position of the two anchor points determines the effect of the curve.

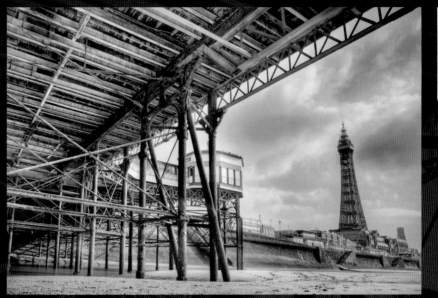

Increasing contrast in the shadow areas

Working with S-Curves

One of the most useful Curves is typically referred to as an S-Curve, because it is in the shape of a flattened letter "S." Typically, an S-Curve will have two anchor points—an upper point to lighten the lighter parts of the image, and a lower point to darken the shadow areas, as shown in the examples above. This increases the contrast in an image, but because the white and black points in the Curve aren't usually moved, there's no risk of clipping the shadows or highlights.

How to construct a Curve

As previously noted, the steeper a curve, the greater the increase in contrast. However, when working with S-Curves, not all of the Curve can be steep—both ends become progressively more shallow as they move towards either the white point or black point. This means you need to decide which sections of the Curve to make steep, and which to make more shallow. For example, if your aim is to maximize the contrast in the darker areas of the image, then the steepest section of the Curve should be toward the bottom-left corner—the shadow/black point end. This will expand the tonal range in the shadow areas of the image which, in this case, really brings out the detail under the pier (above). What you will also notice is that the contrast in the lighter areas of the original image—the sky and brighter sections of structure—is now much lower. This is because the section of the Curve toward the top right that controls the highlight detail is now much flatter.

Alternatively, if you decided that you wanted to maximize the contrast in the highlight areas, you could set your curve accordingly. In this instance, the steepest section of the Curve needs to be toward the top-right corner of the dialog, to expand the tonal range in the highlight areas, while but decreasing the contrast in the darker areas (opposite, top).

Ultimately, it is this control that makes the Curves tool something you will certainly want to explore further when modifying your LDR images. Initially, it can be a little tricky to get to grips with Curves, and there are no clear guidelines I can give you as each image is different, and each requires adjusting in a different way. A gentle S-Curve is often a good place to start, but beyond that it only becomes easier to use with practice.

Increasing contrast
in the highlight areas

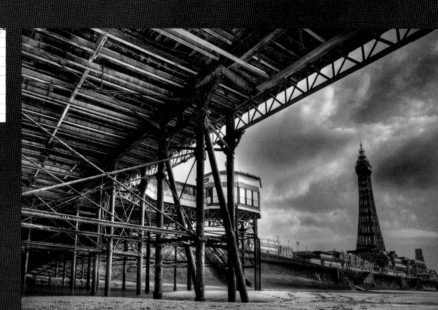

Before Curves adjustment

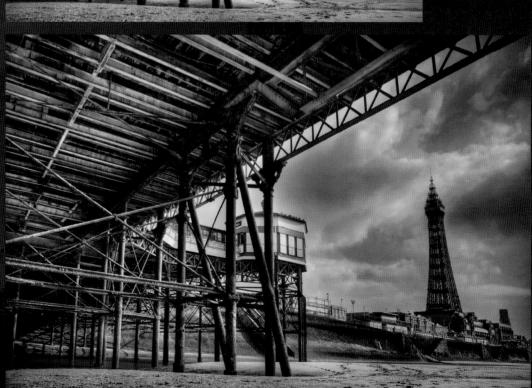

After Curves adjustment

◀

Original image

▼

Unifying the
tonal range

Creating Single-Image HDRs

Original image

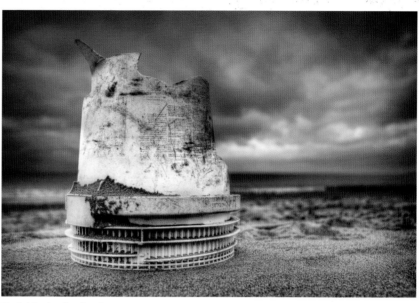

Maximizing local contrast

So far, all of the techniques we have looked at center on producing a final image from a bracketed sequence of shots, but it is also possible to tone map a single Raw file using Photomatix Pro's Details Enhancer. However, as starting with a bracketed sequence will nearly always produce a better result, why would you want to use this technique?

The first, and simplest, answer is that it allows you to create the HDR "look" without the need for a series of bracketed exposures. This means it can be applied to any Raw file you may have taken.

Second, it provides a relatively straight-forward way to unify the tonal range within an image, so you can balance the foreground illumination to the sky, for example. Also, because this technique maximizes the local contrast, it can be used to bring out every last detail within an image, without the need for complex masking and selective adjustments.

Finally, there are times when it simply isn't possible to shoot a bracketed sequence—such as when the subject is moving. These reasons are not exclusive to one another—you can create the HDR look, unify the tonal range, and maximize detail at the same time—but there are several ways you can increase your chances of producing a final image with as little noise and as few processing artifacts as possible.

Optimizing the exposure

The key to a successful HDR image constructed from a set of bracketed exposures is to shoot a sequence that covers the entire dynamic range of the original scene, and the same holds true for a single image HDR. In this instance, though, you only have a single exposure to work with, so you ideally need to make sure that the dynamic range of the scene is lower than your camera's dynamic range from the outset—any shadow or highlight clipping at the exposure stage will be carried through to the final image.

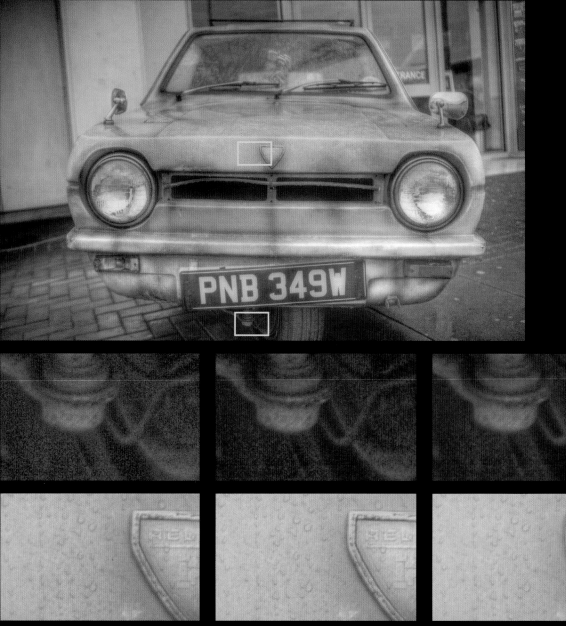

Tone mapped directly from Raw file
in Photomatix Pro.

Converted from Raw to 16-bit TIFF
using Adobe Camera Raw, then tone
mapped in Photomatix Pro.

Converted from Raw to 16-bit TIFF,
with increased noise reduction.

Pre-processing an image

When working with a bracketed sequence of exposures I would recommend that you work with Raw files whenever possible, but for single image HDR's this can cause problems, particularly in terms of introducing unwanted noise. The image opposite was tone mapped twice in Photomatix Pro; first from the original Raw file, and then from a 16-bit TIFF generated using Adobe Camera Raw's default settings. Then tone mapping settings were the same for each version.

If you look at the details from these two conversions (opposite, bottom left and bottom center) you can see that the noise in the dark area is obvious in the image that was tone mapped directly from the Raw file, although this doesn't have any impact on the area in the centre of the car's hood. Conversely, there is considerably less noise in the darker areas of the tone mapped TIFF.

The reason for this is the noise reduction algorithms in Camera Raw are more sophisticated than those in Photomatix Pro, so tone mapping a pre-processed Raw file produces a much cleaner final image. What you may also have noticed though, is that the lighter area in the TIFF image now looks a bit softer.

The TIFF file was initially created with Camera Raw's default noise reduction settings (Luminance: 0 and Color: 25), and if we increase the amount of noise reduction—in this instance to Luminance: 50 and Color: 50—the darker areas of the image are almost entirely free from noise (opposite, bottom right). At the same time, though, this removes a noticeable amount of detail from the highlight areas as well.

The problem here is that there is no reliable way of working out how much noise reduction you need to apply to prevent noise in the shadow areas of the final, tone mapped image. This is because the amount of noise is proportional to the strength of the tone mapping you apply, and the areas of the image that will be affected the most are the darkest areas, which are inherently difficult to evaluate, precisely because they are so dark. My advice is to use the default noise reduction settings, but be prepared to produce a version with a higher amount of noise reduction if necessary. Alternatively, if there is still some residual noise in your image, remove it using a noise reduction plug-in, such as Noise Ninja.

Generating a pseudo-HDR image

Once you have produced a 16-bit TIFF from your original RAW file you can generate the pseudo-HDR image. Open your TIFF file in Photomatix Pro (File>Open) then choose Tone Mapping from the Process menu. This will open the main tone mapping dialog that we covered in the previous chapter.

Tone mapping a single file is done in exactly the same way that you were shown in chapter five, but you should note that because pseudo-HDR files contain less data than an HDR file generated from a bracketed sequence of exposures, they often need to be processed more conservatively, so you may not be able to produce as dramatic a final image as you would like without introducing obvious processing artifacts.

Converting a Raw file to black and white, and then tone mapping the monochrome file can produce great results.

Enhancing Low Contrast Scenes

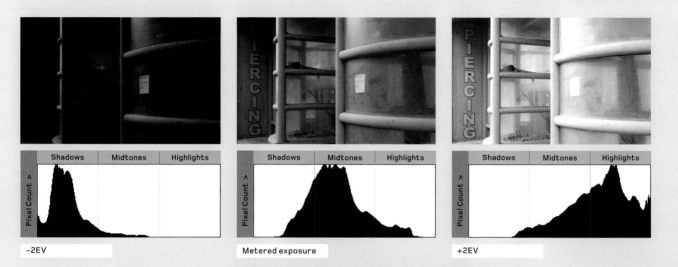

Shadows	Midtones	Highlights

−2EV

Shadows	Midtones	Highlights

Metered exposure

Shadows	Midtones	Highlights

+2EV

The majority of HDR techniques involve creating images from scenes with an EV range exceeding that of your camera, but they can also be used to enhance scenes with a lower EV range that could be captured in a single shot.

The histograms for the three images of a disused piercing parlor used here show that the metered exposure captures the full EV range of the original scene. Simply increasing the contrast for the metered exposure produces an acceptable image (right), but it's quite different to a tone mapped version created from all three frames (opposite).

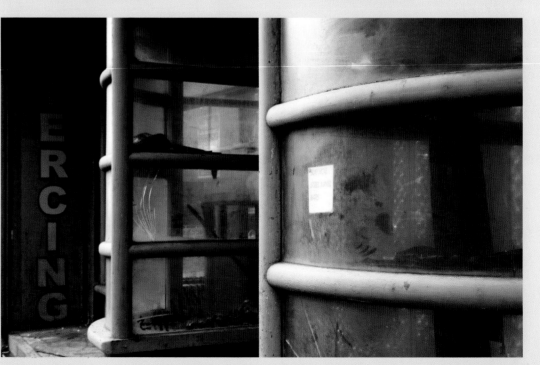

A Curves adjusted version of the metered exposure

The top section of the sign on the left of the image is much darker in the version constructed from the metered exposure, while the text on the small piece of paper in the window is much clearer in the tone mapped version. There is also a lot more fine scale detail in the tone mapped image, which is most noticeable in the brighter sections of the windows where you can see every scratch and smear. Overall, the tone mapped version has a much more evenly distributed range of tones than the metered exposure.

Shooting a low contrast scene is a lot easier than shooting a scene with a high EV range, because a three-shot brack-eted sequence cannot fail to capture the entire EV range of the original scene. All I would suggest is that you check the histogram of your metered exposure to make sure it isn't especially biased to either the highlight or shadow detail, then shoot a three-shot sequence using a 2EV spacing. Once you have generated your HDR image you are ready to move on to the tone mapping.

Again, you can proceed with this stage of the process much as we have in previous sections of the book, adjusting the various sliders and controls until you are satisfied with the result. In practice, your aim will be to unify the tonal range of the different areas of the original scene, although each image is different, so each will require some fine-tuning of the settings to produce the best result.

The tone mapped image

FDRTools and Photoshop

While I used Photomatix Pro to tone map and generate the HDR images in this section, you can also use FDRTools and Photoshop, although Photoshop's tone mapping options are considerably less effective. While you can go through the motions of generating an HDR image, all of Photoshop's four tone mapping tools will leave you with an image that looks almost identical to the metered exposure. While Photoshop can do a good job of compressing the global contrast of a scene with a large EV range, it does so without introducing much local contrast. This means it can't unify the tonal range across different areas of the image in the same way as the other programs.

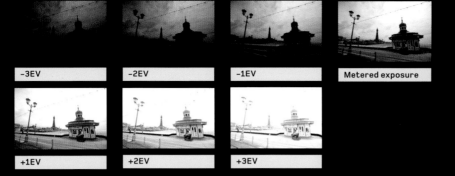

-3EV

-2EV

-1EV

Metered exposure

+1EV

+2EV

+3EV

"Moderate"
tone mapping

Photomatix Pro Details
Enhancer settings

Strength: 71

Color Saturation: 17

Luminosity: 3

Light Smoothing: High

Microcontrast: 10

White Point: 0.000

Black Point: 0.015

Gamma: 0.58

Micro-smoothing: 12

(other settings left
at default values)

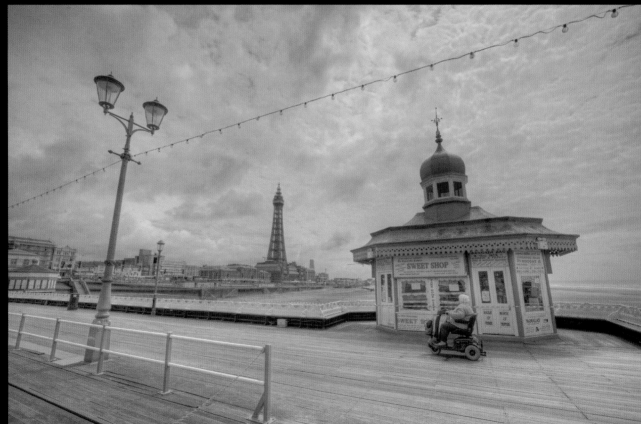

Up until this point, the workflow we have followed (other than discussing how to tone map a single image), has followed much the same pattern:

- Shoot a bracketed sequence of exposures of the original scene.
- Create a 32-bit HDR file from the bracketed exposures.
- Tone map the HDR file into an 8-bit or 16-bit LDR file.
- Carry out post-production.

For the most part, this four-step workflow is all you need, and it works well with most image sequences. However, there are times when the tone mapping stage can be problematic, and trying to determine which settings to use isn't clear-cut.

As you can see from the original set of exposures for this image, this scene would have been very difficult to

photograph in a single shot, as in the metered exposure the sky is clearly overexposed, yet the small building is very dark. This is clearly an ideal scene for creating an HDR image, but what tone mapping settings should you use? If you take a look at the examples opposite and below, you can see that one version is much more extreme than the other, and if you look at the settings for the two versions, you can see why.

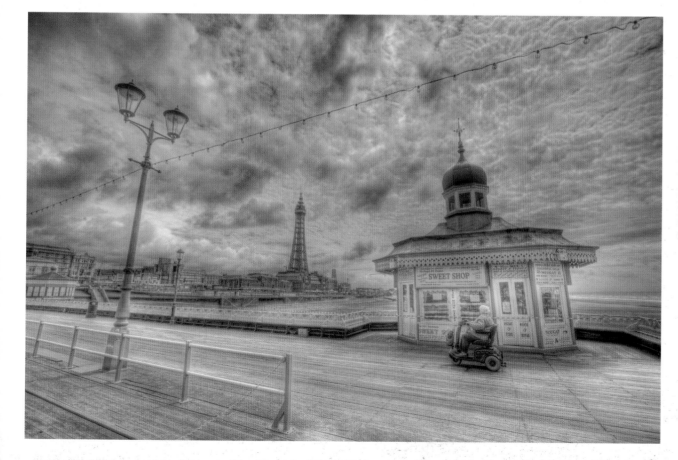

"Extreme" tone mapping

Photomatix Pro Details Enhancer settings

Strength: 100

Color Saturation: 17

Luminosity: 10

Light Smoothing: Medium

Microcontrast: 10

White Point: 0.000

Black Point: 0.015

Gamma: 0.58

Micro-smoothing: 2

(other settings left at default values)

At this stage, both versions lack contrast, but this can be increased by adding a reasonably strong S-Curve. This clearly improves both images (below), and makes the sky even more dramatic in the extreme version.

You might prefer one version to the other at this point, in which case you could simply produce one tone mapped image using the settings of your choice. But if you think there are aspects of each version that have merit things get a bit more complicated. For example, while I like certain elements in the extreme version—the detail on the pier, the light on the small building, and the woman in front of it—the sky is a bit too dramatic, and draws the viewer's attention away from the foreground.

Based on what we have discussed so far, this leaves us with three choices; we can go with the extreme version, and accept that we don't much like the sky; we could use the more moderate settings and sacrifice some of the detail in the foreground; or we could try tone mapping settings that are a compromise between the two extremes. But, if we aren't entirely happy with either image, and don't want to "compromise" on the picture, there is a fourth option that will let us retain the best aspects of both versions: we can merge both tone mapped images in Photoshop and take the best parts of each one.

To do this you first need to create both tone mapped versions of the image and save them as 16-bit or 8-bit TIFF files.

Having generated a pair of tone mapped images, open both images in Photoshop. Select the extreme version (Select>All), switch to the moderate image file, then click Edit>Paste to paste the extreme image as a new layer, immediately above the background layer of the original document. If your layers palette isn't visible, choose Window> Layers. This will show the two layers in your document: "Background" and "Layer 1" (*pic A*).

At this stage the moderate version won't be visible because the upper layer is concealing it, so we need to merge the two versions. To do this, add a Layer Mask to the new layer (Layer>Add Layer Mask> Hide All). This adds a black layer mask to the layer (*pic B*), and the Background layer is the one that is visible.

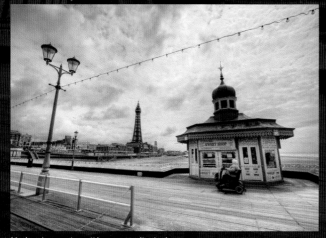

Moderate version with curves adjusted

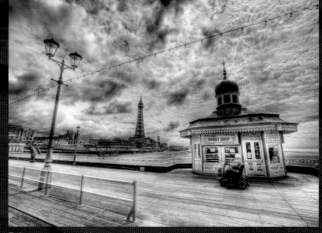

Extreme version with curves adjusted

To merge the layers, simply erase parts of the newly created mask using the Eraser tool to "reveal" the areas of the top, extreme image that you want to show. You need to make sure that the layer mask is active, not the content of the layer—the active element of the layer is indicated by a broken border around its thumbnail in the layers palette (pic C).

You can now start erasing areas of the layer mask, but there are a few things you should bear in mind with the Eraser tool, namely the size and hardness of the brush you use, and its opacity.

To control the size and hardness of the Eraser tool, right-click on your image to bring up a dialog that lets you change both. Set a brush size that's large enough to remove the sections of the mask you want to erase without taking too much time, but not so large that you inadvertently erase sections you want to retain.

The hardness setting refers to how defined the edge of the eraser will be when removing areas of the mask. A hardness setting of 100% has a clearly defined edge, while a hardness setting of 0% does not, making the blend much smoother (pic D). In practice, it's almost always better to use a "softer" brush with a setting closer to 0% than 100%, as this will mean that the changes are applied in a more natural way.

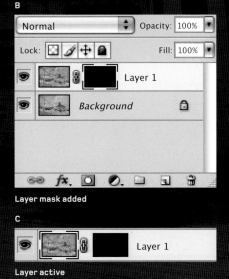

A
Pasted layer

B
Layer mask added

C
Layer active

Layer mask active

D
The hardness of the Eraser defines the sharpness of its edges

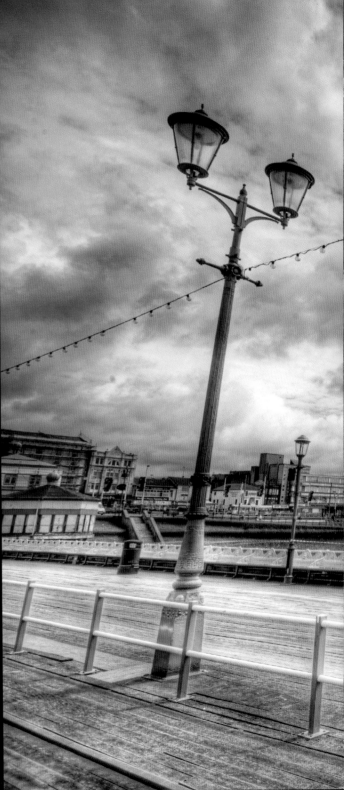

With this image, the aim is to remove the section of the mask at the bottom of the picture, so the more extreme version is visible in this area. This will produce a picture that combines the detail in the foreground of the more extreme version with the moderate sky.

As you erase the mask you can change the Opacity of the eraser using the slider on the toolbar. The Opacity controls the strength of the eraser, and set to 100% it will completely erase an area of the mask when you click on it, allowing the underlying image to show through fully. However, if you set the opacity to 50%, only half of the area you click on will be erased, so in this example the result would be a patch that is half "extreme" and half "moderate." By varying the Opacity as you work, you can control more precisely the blending of the two images.

While this blending technique is clearly a time-consuming one—not least because you need to produce two (or more) tone mapped versions of your HDR image to start with—it can be used to great effect, especially when the only other alternative is to produce an image that compromises the detail in one area to avoid making another area look too extreme. Compared to both the extreme and moderate tone mapped versions of the original image, my finished picture is clearly "the best of both."

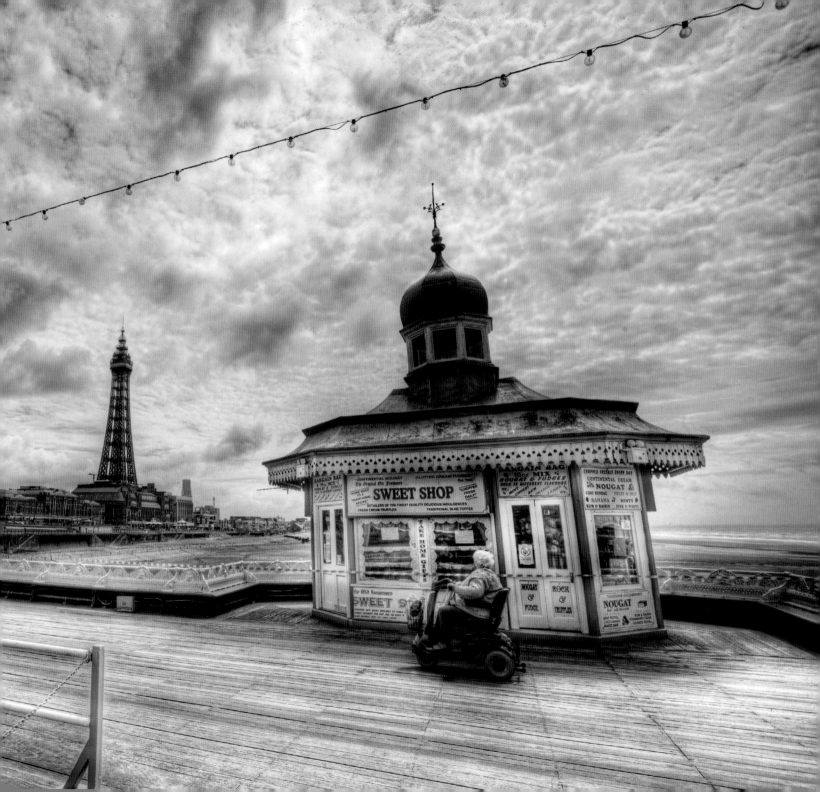

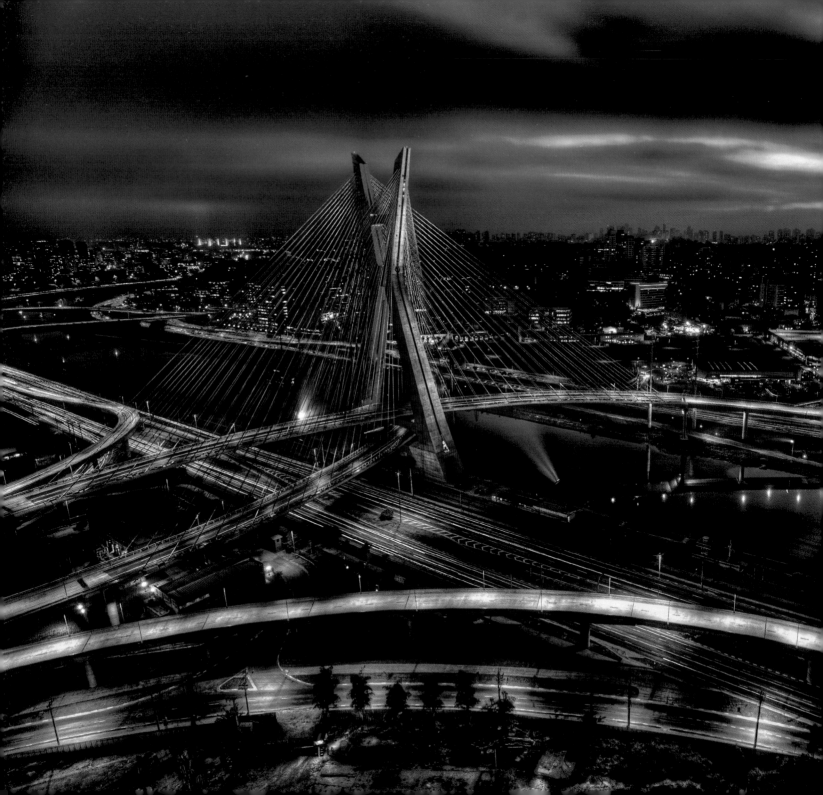

▲
Reflections of Honfleur
Michael Steighner

◄
View from the Hilton
Mombai in Sao Paulo
Michael Steighner

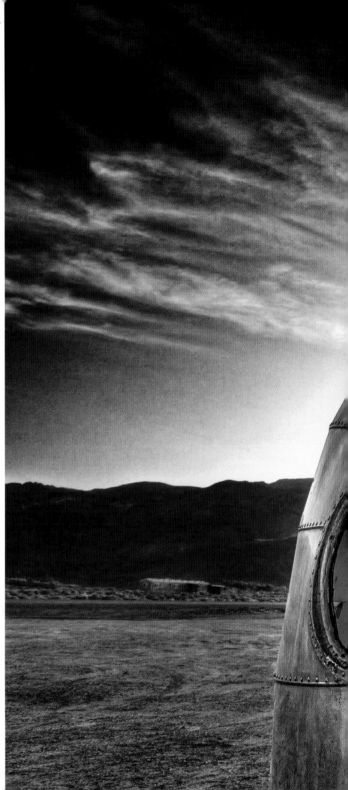

▲
*As Wednesday comes
to a close at the DNC*
Michael Steighner

▶
Lost Capsule
Ben Willmore

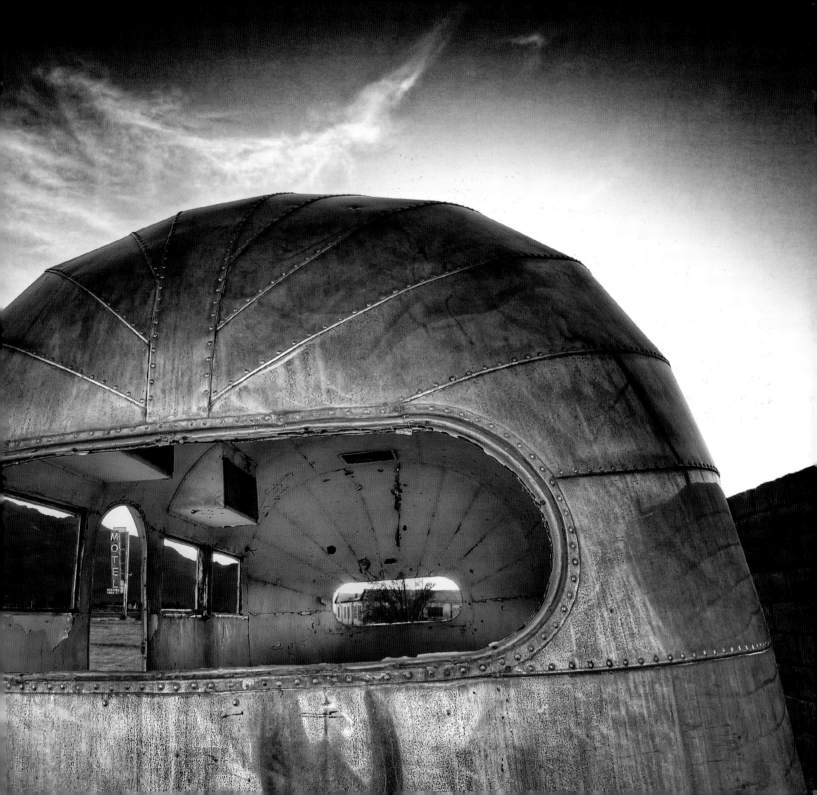

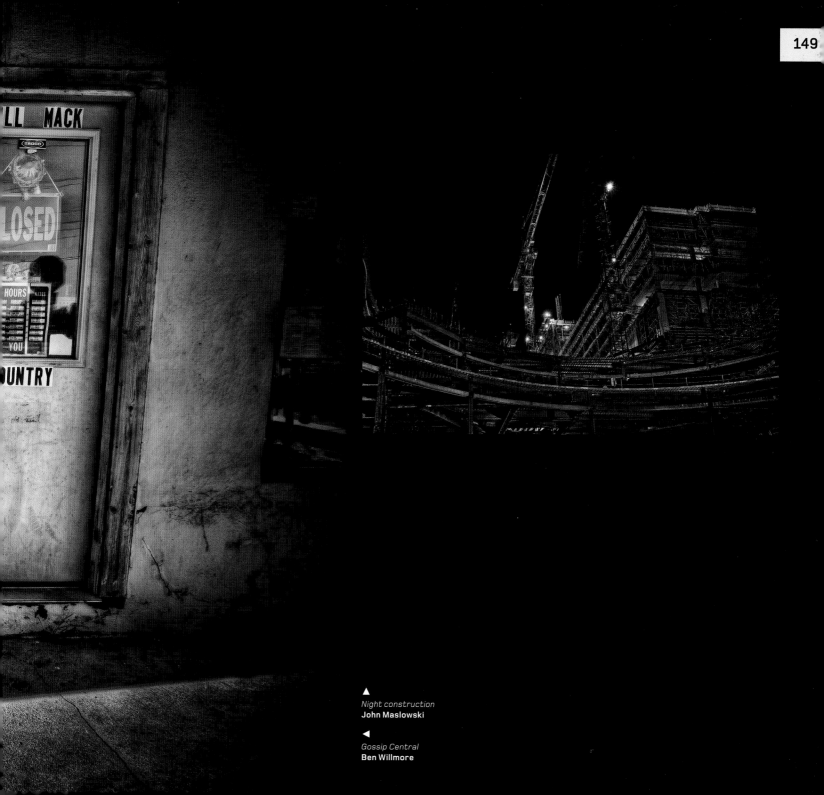

▲
Night construction
John Maslowski

◄
Gossip Central
Ben Willmore

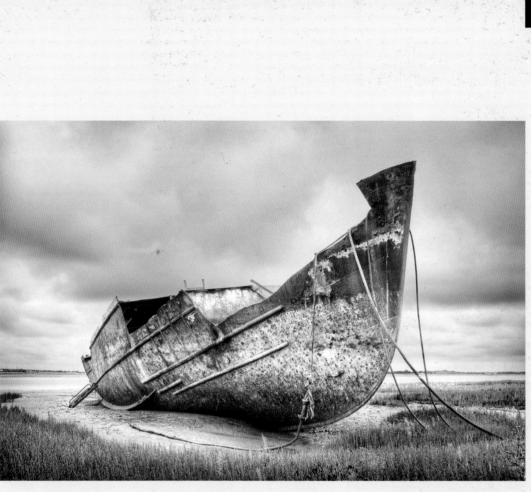

▲
Wyre wreck II
David Nightingale
◄

*Through the
looking glass*
Ben Willmore

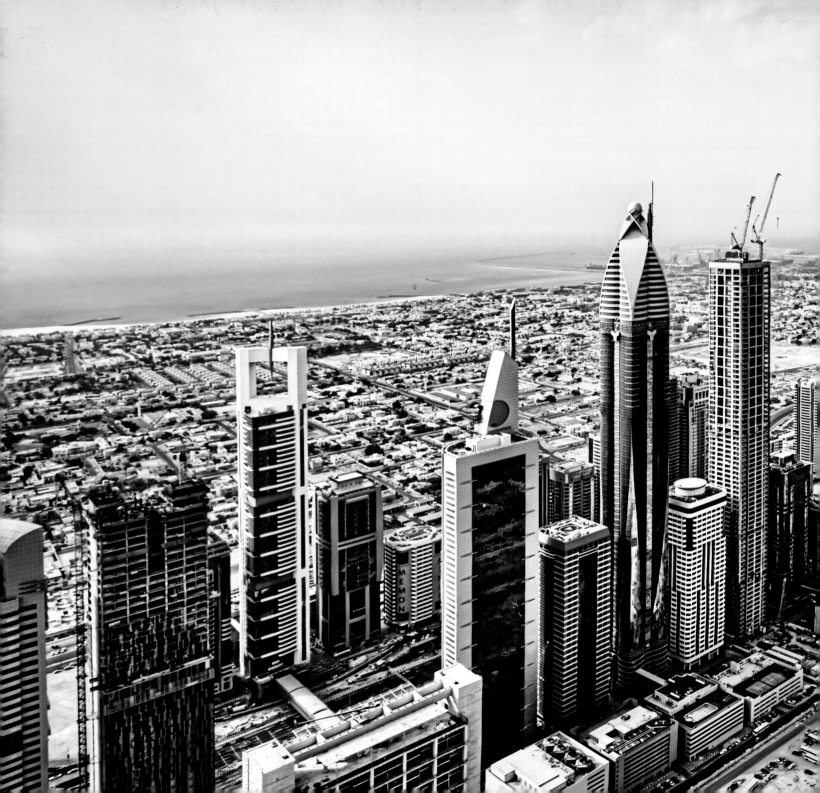

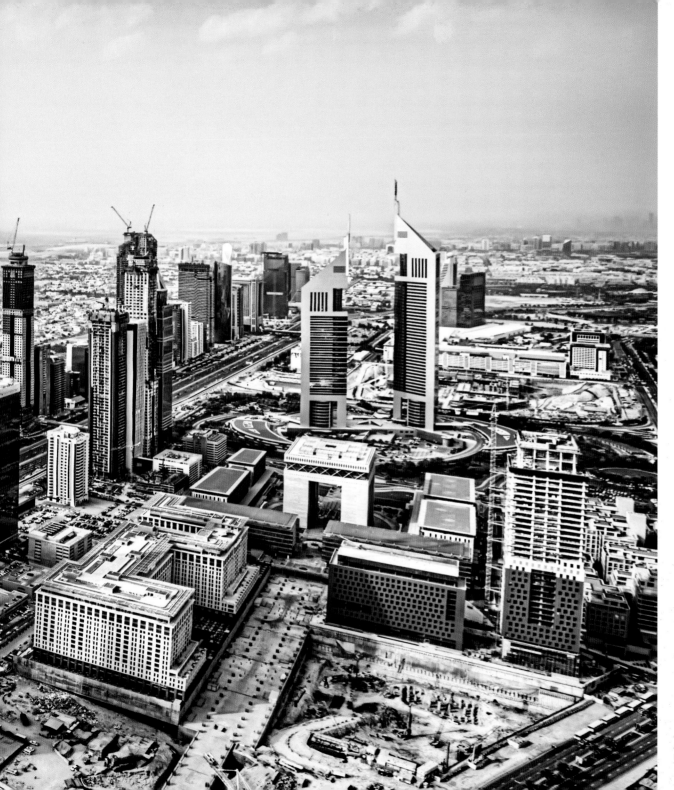

Sheikh Zayed road
David Nightingale

Glossary

Auto-bracketing A method of automatically shooting a sequence of images to produce a set of differently exposed photographs that can be combined into an HDR image. While it is possible to auto-bracket on the basis of shutter speed, ISO, and aperture, only the latter is useful for HDR photography.

Bit depth The number of bits (of data) that are used to record the data in your images. A JPEG file is encoded with 8 bits of data per channel; a RAW file typically uses 12 bits of data, while a decoded RAW file can contain 16 bits of data per channel. An HDR file, on the other hand, contains 32 bits of data per channel.

Black point Within Photoshop, or other image-editing programs, the black point refers to the adjustment point that can be used to remap a particular point in the tonal range to black. In practice, this means that any value equal to, or lower than, the set value will be black in the final image.

Bracketing In HDR photography, bracketing refers to the process of shooting a range of exposures using different shutter speeds at a constant aperture to capture the entire dynamic range of the original scene. See auto-bracketing.

Clipping When shadows are underexposed, or highlights overexposed to the point that image detail is lost, they have been "clipped." This can be caused by selecting the wrong exposure or, in the context of HDR photography, when the dynamic range of the scene is larger than can be recorded by your camera's sensor.

Contrast ratio The ratio of brightness between the lightest and darkest tones in a scene or image. A typical camera's sensor can record a contrast ratio of up to 500:1 while the human visual system can adapt to a contrast ratio of 10,000,000:1.

Curves A feature in most image-editing programs, Curves adjustments are often used to increase the global contrast in a tone mapped image.

Details Enhancer The Details Enhancer is one of two methods of tone mapping that are available to you within Photomatix Pro. This method offers a high degree of control over the appearance of your final image and is ideal when you want to produce a more surreal result.

Dynamic Range The dynamic range of a scene refers to the ratio between the luminance of the lightest and darkest areas of the scene. A scene with very bright highlights and deep shadows will have a large (or wide) dynamic range, while a shot with dull highlights and soft shadows will have a smaller dynamic range. When used to refer to a camera's sensor, dynamic range is often referred to in terms of the number of f-stops or the EV range that can be captured before the highlights or shadows become clipped. Most DSLRs' sensors have a dynamic range in the region of 5–9EV.

Equalize Histogram Equalize Histogram is a method of tone mapping your images within Photoshop. For most HDR images this will often produce a tone mapped image with clipped highlights and shadows, so it is not a useful method in most circumstances.

Exposure Value (EV) Exposure Value is a term that denotes the combinations of shutter speed and relative aperture that give the same exposure. For example, an aperture of f/2.8 and shutter speed of 1/60 sec will give the same exposure as f/4.0 and 1/30s, so both have the same Exposure Value.

Exposure and Gamma Exposure and Gamma is a tone mapping option within Photoshop that allows you to control the highlight and mid-tone values within the tone mapped image.

Exposure Blending Combining an original sequence of bracketed exposures to produce a composite image derived from the dynamic range of the entire sequence. This isn't an HDR technique, but can be used to create a final picture from a scene where the EV range is much higher than your camera's dynamic range.

F-stop The f-stop is a ratio of the focal length of the lens to the diameter of the aperture. The value is in increments that allow half as much or twice as much light to reach your camera's sensor as the previous stop.

Ghosting Ghosting can occur within a tone mapped image when one or more components within the original scene moved between exposures, leaving faint traces, or "ghosts," in the final image.

Global contrast The overall contrast of an image. Adjusting the global contrast of an

image changes all elements in the picture by the same amount.

Haloing Halos (lighter areas around the edges of objects)are artifacts introduced by the tone mapping process.

HDR or HDRI Abbreviations of High Dynamic Range and High Dynamic Range Images (or Imaging).

Histogram The histogram, either in-camera or within your image editing software, provides a visual summary of the distribution of the tonal range within an image. This is an especially useful tool in the context of HDR photography.

Hyper-realism While HDR techniques can be used to produce photo-realistic results they can also be used to produce "hyper-real" images that have a more illustrative, or painterly appearance.

LDR Abbreviation of Low Dynamic Range. In the context of HDR photography, an LDR image refers to an pictures with a dynamic range that can be captured and displayed on conventional LDR device such as a computer monitor or photographic paper. All HDR images are tone mapped to create LDR images for viewing or printing.

Local Adaptation The most useful method of tone mapping an image within Photoshop. Local Adaptation provides control over a variety of parameters including a tone curve to adjust the tonal balance of the final image.

Local Contrast The degree of contrast within specific areas of an image. Many tone mapping processes allow you to independently control local and global contrast, so distinct areas of the image can be adjusted individually.

OpenEXR A common file format for saving 32-bit HDR images as it preserves the data in the image.

Photo-realism In the context of HDR photography a photo-realistic image is one that is tone mapped to approximate the appearance of reality.

RGBE (Radiance) RGBE or Radiance is a common file format that can be used to save your 32-bit HDR images, although it can sometimes introduce slight color shifts in some images.

Tone Compressor A tone mapping operator in Photomatix Pro. This method can be used to produce photo-realistic results from sequences of images where the EV range is high.

Tone mapping Tone mapping is the process whereby a 32-bit HDR image is converted into an LDR image. The large EV range of an original scene is compressed into an image that can be displayed and viewed using conventional LDR technology.

White point Within Photoshop, or other image editing software, the white point refers to the adjustment point that can be used to remap a particular point in the tonal range to white. In practice, this means that any value equal to or higher than the set value will be white in the final image.

HDR SOFTWARE

Adobe Photoshop
www.adobe.com

FDRTools
www.fdrtools.com

Photomatix Pro
www.hdrsoft.com

Dynamic-PHOTO HDR
www.mediachance.com

easyHDR
www.easyhdr.com

Hydra
www.creaceed.com

pfstools
www.pfstoolssourceforge.net

CONTRIBUTORS

David Nightingale
www.chromasia.com

Ricardo Aguilar Herrera

Pete Carr
www.petecarr.net

Catalin Marin
www.momentaryawe.com

John Maslowski
www.sirius2photo.com

Brooks Potteiger
www.brookspotteiger.com

Michael Steighner
www.mdsimages.com

Trey Ratcliff
www.stuckincustoms.com

Ben Willmore
www.thebestofben.com

Index

Acknowledgments

This book would not have been possible without the help of a variety of contributors who kindly agreed to allow me to use their work, so I would like to offer my sincere thanks to Ricardo Aguilar Herrera, Pete Carr, Catalin Marin, John Maslowski, Brooks Potteiger, Michael Steighner, Trey Ratcliff, and Ben Willmore.

I would also like to thank my wife, Libby, for proofreading various sections of the book, offering critiques of the photographs I took for the project, and for generally putting up with me as I worked through a large number of evenings and weekends to get it finished. It wouldn't have been possible without her.

And last (but not least), I would like to thank Craig (www.id7.co.uk) for proofreading some of the more technical sections of the book.